IMAGES
of America

CLEVELAND HEIGHTS

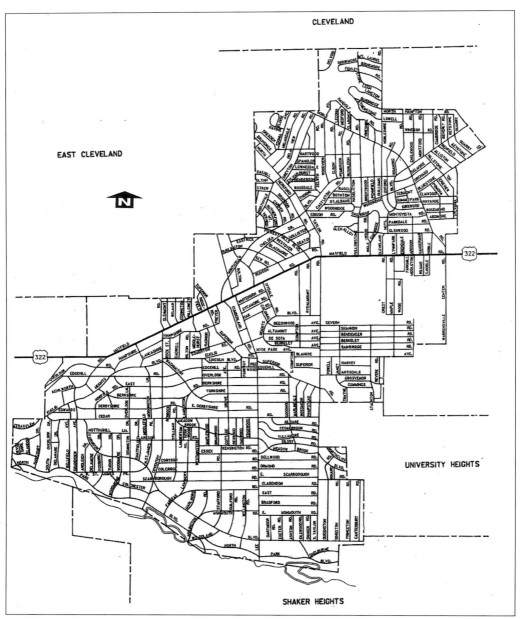

THE MOSAIC OF CLEVELAND HEIGHTS, 2004. Superimposed upon the orderly 100-acre tracts laid out by the Connecticut Land Company are the irregularly shaped boundaries of Cleveland Heights, created by its initial secession from East Cleveland Township and by later annexations of portions of Shaker, Idlewood, and Bluestone Villages. Within these boundaries are the grid street plans of Cedar Heights, Minor Heights, and Mayfield Heights, borrowed from urban land design, as well as the curvilinear streets of more ambitious allotments like Euclid Heights, Ambler Heights, and Shaker Village, and the second Forest Hill development that strove for suburban elegance. The map also illustrates the small and more generous lots in different neighborhoods and the large open spaces for the parks, schools, a country club, and a giant mall that make up the mosaic. (City of Cleveland Heights.)

IMAGES
of America

CLEVELAND
HEIGHTS

Marian J. Morton

ARCADIA

Published by Arcadia Publishing
Charleston SC, Chicago IL, Portsmouth NH, San Francisco CA

Printed in Great Britain

Library of Congress Catalog Card Number: 2004117692

For all general information contact Arcadia Publishing at:
Telephone 843-853-2070
Fax 843-853-0044
E-mail sales@arcadiapublishing.com
For customer service and orders:
Toll-Free 1-888-313-2665

Visit us on the internet at http://www.arcadiapublishing.com

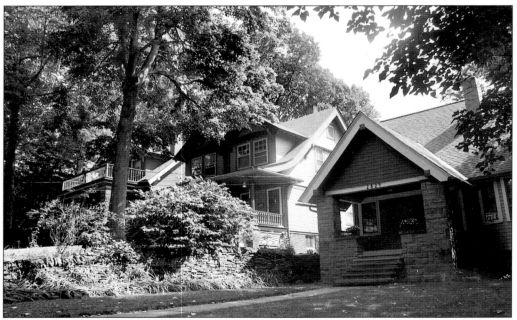

STREETSCAPE. This cluster of homes ascending Hampshire Road from Coventry Road demonstrates the eclectic tastes and varied aspirations of early suburban home owners. The single and double homes that line this street—Arts and Crafts bungalows, American four-squares, Victorian Queen Anne shingles, and colonial revivals—were built between 1900 and 1920, a period of rapid population growth in Cleveland Heights that led to the hamlet of 1,500 becoming a city of 15,264. (James W. Garrett IV.)

CONTENTS

ACKNOWLEDGMENTS

"You're writing *another* book on Cleveland Heights?" people asked. Well, okay: some of this story and a few of the photographs will be familiar to readers of *Cleveland Heights: The Making of an Urban Suburb* (Arcadia Publishing, 2002). But I hope that much will be new, especially the maps, postcards, and photographs that re-create this history of Cleveland Heights.

I want to thank many people for those images and other assistance. First, John Carroll University for its generous financial support.

Also, Craig Bobby; Michael Doherty (Cleveland Heights-University Heights Board of Education); Forest Hill Presbyterian Church; Noreen Fox (Community Relations, City of Cleveland Heights); Edward H. Frost; Connie Gillen and Kate Klaber (Church of the Redeemer); Sharon Gregor; Sue Hanson (Special Collections, Case Western Reserve University); Frances Crouse Helsing; Kay Heylman; Hope Lutheran Church; Susie Kaeser (Reaching Heights); Richard Karberg; Paul Klein; Chris Krosel (archivist, Cleveland Catholic Diocese); Karen Laborde; Ben Lewis; Eric Linderman (East Cleveland Public Library); Eleanor Richardson (Church of the Saviour); Anne Salcich (Western Reserve Historical Society and Ursuline College); Marie Salkin; Nancy Schwab; Charlene Warner (Coventry School); Roy Woda; and Diana Woodridge (Home Repair and Resource Center).

As always, special thanks to James W. Garrett IV for his splendid photographs, his inspiration, and his patience and skill as a researcher.

Finally, this book is dedicated to Kara Hamley O'Donnell, historic preservation planner of Cleveland Heights, for her energy, enthusiasm, and expertise, which have encouraged Cleveland Heights' residents to preserve and enjoy their past.

INTRODUCTION

During its more than a century as a suburb, Cleveland Heights has evolved as a rich mosaic of places and people. No one planned it that way. Instead, Cleveland Heights was shaped by the natural topography (the "heights" above the City of Cleveland that gave the suburb its name); by technology (streetcars and automobiles); by enterprising developers (with very different tastes and markets); by elected officials (sometimes); and by its residents of many backgrounds.

Cleveland Heights was originally part of East Cleveland Township, which was created in 1847 out of the Western Reserve of Connecticut. Early residents of this southeastern section of the township owned dairies, farms, orchards, vineyards, and quarries and sold what they produced in nearby Doan's Corners or the more distant, booming industrial city of Cleveland. As the electric streetcar narrowed that distance in the 1890s, Clevelanders who could afford it moved away from the smoky factories and the congested neighborhoods of the city, east and west into its first suburbs. In 1900, 92 residents of the neighborhood on the fourth glacial terrace south of Lake Erie voted for autonomy from East Cleveland Township (four voted against). Thus, the hamlet of Cleveland Heights was born, and voters chose its first trustees in 1901.

Very different versions of suburbia had already taken shape in the new hamlet. In the 1890s, William and Edmund Walton had begun to build homes in the hilly countryside that became their Cedar Heights development. Intended for middle-income families, the spacious homes with Victorian decorative detail were urban transplants on small lots. In contrast, the first mansions of Patrick Calhoun's Euclid Heights were intended to rival those on Cleveland's "Millionaires' Row," Euclid Avenue. The largest and most ambitious of Cleveland Heights allotments, Euclid Heights developed quite differently than Calhoun had intended after his bankruptcy in 1914. Almost simultaneously with Calhoun and the Waltons, Marcus M. Brown developed Mayfield Heights on property purchased from J.P. Preyer. Brown built gracious homes with wide porches for "thrifty, intelligent, and worthy citizens" near early churches and civic institutions. Preyer's son, Emil C. Preyer, also planned a suburban development on his father's vineyard that became, instead, Cumberland Park.

Cedar Heights, Euclid Heights, and Mayfield Heights benefited from the streetcar line built by Calhoun up Cedar Glen, east to Euclid Heights Boulevard and his allotment, and in the first decades of the twentieth century, the extension of the streetcar lines farther east on main thoroughfares—Mayfield Road, Fairmount Boulevard, and Cedar Road—encouraged even greater variety in the suburb's housing and neighborhoods. The suburb's first streetcar ran up Mayfield to the gates of Lake View Cemetery in 1890 and eventually east to Lee and then Taylor

Roads. Along Mayfield, the summer homes of the Severance families became grand country estates; nearby were small developments of modest homes on properties once owned by long-time residents like James Haycox and Seth Minor. On the south side of Cleveland Heights along the Fairmount streetcar line, M.J. and O.P. Van Sweringen, Daniel O. Caswell, Barton R. Deming, and others sold architect-designed homes in new suburban styles to the affluent clientele of Shaker Village, Ambler Heights, and Euclid Golf. Even farther east on Fairmount, the streets of the small farming village of Idlewood were annexed by Cleveland Heights. Long after their suburban development, they have retained their rural character. In the center of the suburb, at the intersection of the Cedar and Fairmount streetcars, a busy shopping center and high-rise apartments developed. In 1921, when Cleveland Heights became a city and its officials established a zoning code to impose order on the suburb's helter-skelter growth, developers and residents had already created these widely various neighborhoods.

Explosive population growth—from 15,264 residents in 1920 to 59,141 in 1950—meant new schools, shops, and houses of worship. Many were built along Noble, Lee, Coventry, and Taylor Roads, which had been made more accessible by the increasing use of the automobile and the extension of bus lines north and south. The school district built, or added onto, its elementary schools: Coventry (1919), Fairfax (1920), Roxboro (1921), Noble (1922), Taylor (1923), Boulevard (1924), Canterbury (1927), and Oxford (1927). Also new were the high school (1926), Roxboro Junior High (1926), and Monticello Junior High (1930). The first chain stores—Kroger's, Fisher Brothers, and the Great Atlantic and Pacific Tea Company—competed with independent bakeries and grocers. Jewish synagogues and temples joined Protestant and Catholic churches, and Jewish neighborhoods grew up along Coventry and Taylor. Although Cleveland Heights' population has changed, Noble, Lee, Coventry, and Taylor remain significant commercial thoroughfares.

Shortly after World War II, the streetcars made their last runs, replaced by busses and especially automobiles. These continued to change where and how suburbanites lived and shopped. The Forest Hill development, laid out in the 1920s by the Rockefeller family but not completed until after World War II, was planned specifically for automobile owners. The Oxford neighborhood also was not fully developed until the improvement of Monticello Boulevard in the 1930s made this northeastern section of Cleveland Heights easy to reach by automobile. The attached garages of the French Norman Rockefeller homes and the post-war ranch houses and colonials acknowledged the importance of the automobile. So did the huge parking lot at Severance Center. Partially compensating for the increased automobile traffic and accommodating to the expansion of these newer neighborhoods, the city developed Forest Hill and Denison Parks.

Although the post-automobile housing was more homogeneous than that of earlier developments, the city's residents were more diverse. Cleveland Heights' population, which peaked in 1960 at 61,813, began a slow decline to slightly over 50,000 in 2000. Families were smaller; residents were less wealthy and less white. Some of the suburb's older buildings adapted to the changed religion, race, and needs of the city's population. The once-distant hamlet had become an inner-ring urban suburb.

So here—in dazzling disarray—comes the Cleveland Heights landscape, past and present: vast mansions and "Cleveland doubles;" simple farm houses and sprawling ranch homes; Arts and Crafts bungalows and English country estates; Victorian Queen Anne shingle homes and 1920s colonial revivals; cluster housing and kit homes; churches, synagogues, and temples; small shops, chain stores, and a giant mall; lots of schools; apartments, parks, parades, pools, parking lots, and public art. And here come Cleveland Heights residents: farmers, developers, industrialists, and small business owners; architects, artists, and musicians; philanthropists and entrepreneurs; politicians and teachers; lots of schoolchildren; senior citizens; professionals and artisans; those who have been rich and not-rich; non-white and white; Protestant, Catholic, Jewish, and many others from different ethnic backgrounds.

I hope you find yourself here.

One

HOMES ON THE HEIGHTS

EARLY VERSIONS OF SUBURBIA

1890–1910

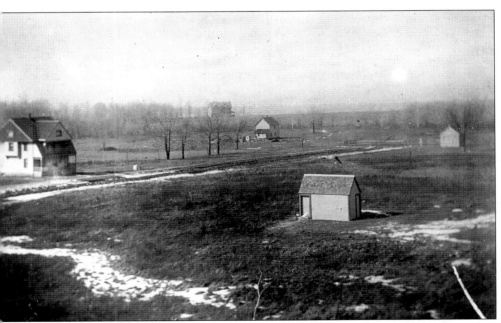

LLFIELD AVENUE, C. 1894. This Cedar Heights home sits almost alone in its rural setting.
the far distance is the grander home built for architect Alfred Granger on Overlook Road in
rick Calhoun's Euclid Heights. To the east of Euclid Heights lay a third, very different
velopment, Marcus M. Brown's Mayfield Heights. (Cleveland Heights Planning and
velopment Department [hereafter CHPDD].)

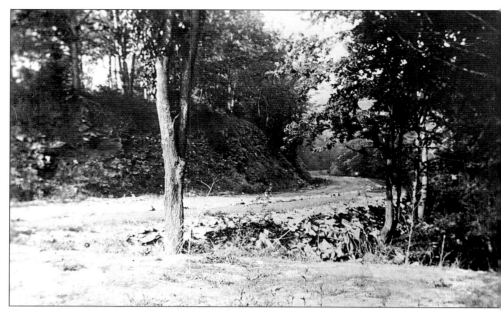

CEDAR GLEN, 1893. Both Cedar Heights and Euclid Heights were initially approached this dirt road, winding east up from the city of Cleveland to "the heights." In 1896, Patrick Calhoun purchased parcels along Cedar Glen from his Euclid Heights allotment west to Euclid Avenue and in 1897 built an electric streetcar line up the hill and east o Euclid Heights Boulevard. (CHPDD.)

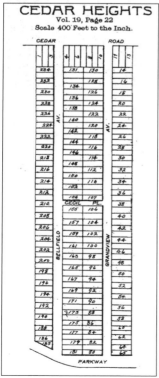

CEDAR HEIGHTS, 1903. The development included only Grandview and Bellfield Avenues and Cecil Place between Cedar Road and what is now called North Park Boulevard, referred to here as "Parkway." The small lots on streets that had been laid out in a grid gave the neighborhood an urban feeling. (Cuyahoga County Archives.)

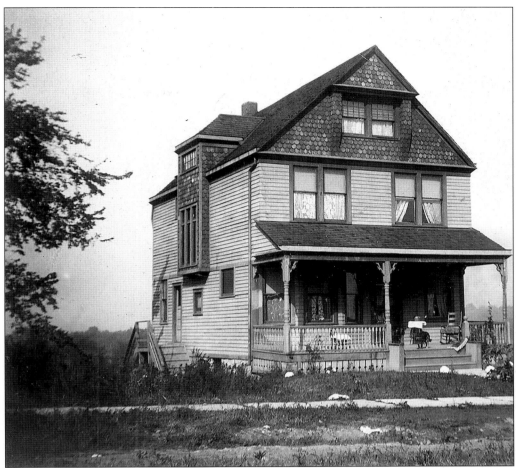

GRANDVIEW AVENUE, 1897. The 1898 plat map shows only six homes on Grandview, including this one, and nine homes, including Edmund Walton's, on Bellfield. Large properties immediately to the east and west of Cedar Heights remained completely undeveloped. This Queen Anne home is distinguished by decorative details such as its side windows, patterned shingles, and porch spindles. Nevertheless, it looks comfortable in the surrounding meadows, as does the dog on the porch. Much modified, this is the TV home of the star of the "Drew Carey Show." (CHPDD.)

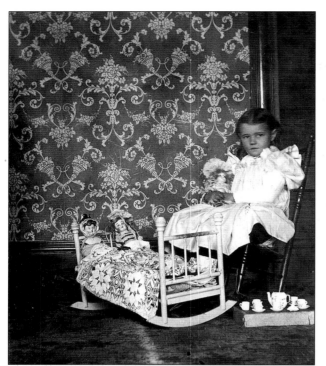

TEA PARTY ON GRANDVIEW, 1897. This charming snapshot was one of several that illustrated the memoirs of a Grandview resident written in 1957. Their author recalled that the homes originally had no "water, gas, electricity, mail delivery or sewers—only a well, a barn, a cow, and some chickens." The interior of this home, however, was as elaborate as its exterior, seen above. (CHPDD.)

WALTON'S HOME ON GRANDVIEW. From 1895 until his death in 1916, Edmund Walton used this spacious duplex as both his home and his real estate office. According to the 1900 census, Walton, then 32, lived here with his wife, daughter, and son, Edmund Jr., who later joined him in the real estate business. (James W. Garrett IV.)

"A Delightful Home" on Grandview. The Waltons did relatively little marketing of their small development, but a 1906 advertisement urged: "[T]his beautiful new home on Cedar Heights will interest you. Very complete. School nearby. A delightful home." The school was Roxboro Elementary. The 1910 census listed on Grandview two salesmen, a bookkeeper, a surgeon, a tool maker, a ticket agent for a railroad, as well as several working women: a kindergarten teacher, a saleslady of millinery, a clerk in a telephone company, and a dressmaker. Almost all were native-born, except for an Irish and a Hungarian servant. (Marian J. Morton.)

Bellfield Residents. According to the 1910 census, Charles S. Faul, 32, born in Ohio of German parents, and his wife Mary, 28, lived on the first floor of this duplex; Faul was the office manager of an automobile company. Upstairs lived Emma L. Tobin, 52, who had her "own income;" her two daughters, Mary, 20, "trimmer millinery" and Eloise, 19, "a saleslady of dry goods;" and an aunt Emmeline Turner, 76, "no occupation." Like Grandview, Bellfield attracted white-collar workers like Faul, but the fact that the young women had jobs indicates that Cedar Heights was middle-class, not affluent. (James W. Garrett IV.)

13

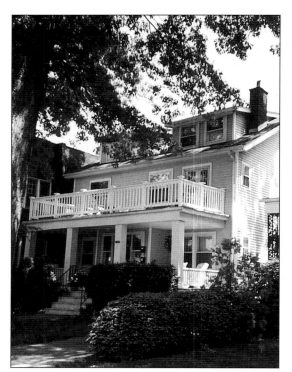

GRANDVIEW DUPLEX. Double homes appear in all Cleveland Heights neighborhoods, but especially in older neighborhoods like Cedar Heights. At least a quarter of the homes built in Cleveland Heights between 1915 and 1919 were doubles. They provided a home-owner like Charles S. Faul with an income, as well as a residence, and allowed Emma L. Tobin and her family to live in the comfortable suburb without having to purchase a home. (Marian J. Morton.)

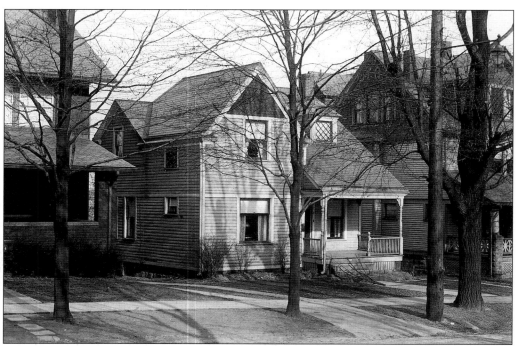

GRANDVIEW, 1927. By the 1920s, Cedar Heights was fully developed. Its homes, small and large, American four-squares and older Victorians, descended down the hill to the Cedar Road streetcar and shops. (CHPDD.)

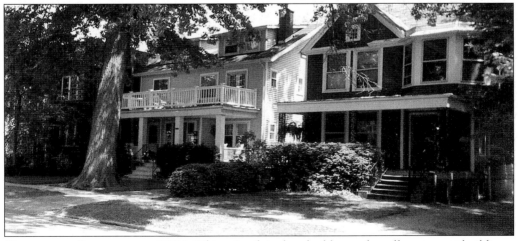

GRANDVIEW, 1930. Here is some of what the census taker recorded about Grandview. Although most of the residents listed were born in this country, many now were of foreign-born parentage, reflecting the ethnic diversity of the greater Cleveland area. Note the families of Morris Cohn and Clarence Moses, sharing the duplex at 2197 Grandview, whose parents were born in Russia and who were probably Jewish. They were among Cleveland Heights' growing Jewish population. (Paul Klein.)

GRANDVIEW STREETSCAPE, 2004.. This mix of singles, doubles, and small apartment buildings, in place before the 1921 zoning code, has made Cedar Heights an unusually varied neighborhood with residents as diverse as the housing stock. (Marian J. Morton.)

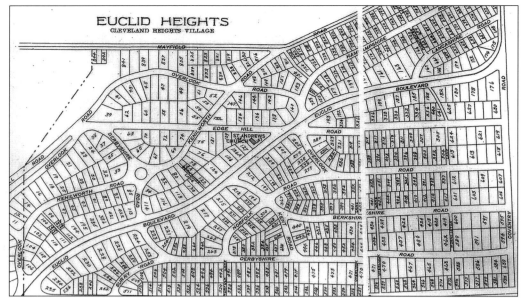

EUCLID HEIGHTS ALLOTMENT, 1903. Initiated in 1891, the allotment originally was bounded by Overlook, Mayfield, Coventry, and Cedar Roads. Laid out by landscape designer E.W. Bowditch, the curving streets at the southwest end of the development were intended to imitate the curves of nature and to distinguish this end of the development, intended for the most affluent homeowners, from the grid streets of Cleveland to the west and Cedar Heights to the south. Euclid Heights Boulevard was often referred to as "Euclid Boulevard" to remind potential buyers of Cleveland's "Millionaires' Row." (Cuyahoga County Archives.)

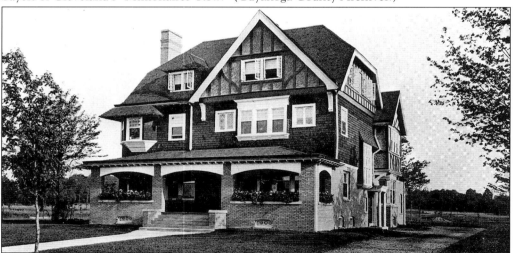

CALHOUN'S HOME ON EDGEHILL. In 1896, the developer built for himself this eclectic Queen Anne-style home, now a designated Cleveland Heights landmark. Unlike the Waltons, Calhoun imposed stringent deed restrictions on his allotment, mandating large lots, single-family homes, and no commercial development. After Calhoun's bankruptcy in 1914, the undeveloped portions of the original allotment were sold at sheriff's auction and were developed as single and double homes, apartments, and the Cedar-Fairmount and Coventry commercial districts. (Western Reserve Historical Society [hereafter WRHS].)

16

VIEW OF "THE OVERLOOK," 1890s. The pillared mansion belonged to entrepreneur and early investor in Euclid Heights, William Lowe Rice; this is now the site of Waldorf Towers. Next door was the home built for Alfred Granger (seen on page 9) and later owned by lawyer M.B. Johnson. This home was purchased in the 1950s by the United Cerebral Palsy Association and is now being converted to condominiums. (WRHS.)

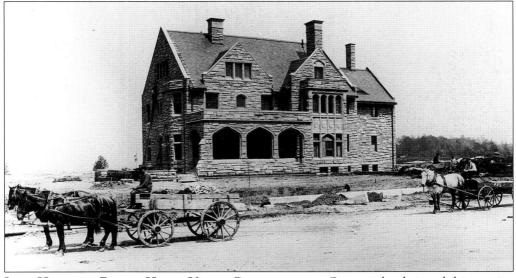

JOHN HARTNESS BROWN HOUSE UNDER CONSTRUCTION. Granger also designed this massive Richardsonian Romanesque mansion, completed in 1896, at Overlook and Edgehill for Brown, also an early investor in Calhoun's allotment. Brown was a business rival of his neighbor, William Lowe Rice, and is sometimes linked to his 1910 murder. (WRHS.)

HORSE AND CARRIAGE ON KENILWORTH ROAD, C. 1902. The handsome brick colonial revival mansion with its striking pillars was the home of industrialist Daniel Connolly. The first homes in this neighborhood had carriage houses, which later became garages and sometimes, as is the case with this mansion, residences. This house still stands, now flanked by apartment buildings. (WRHS.)

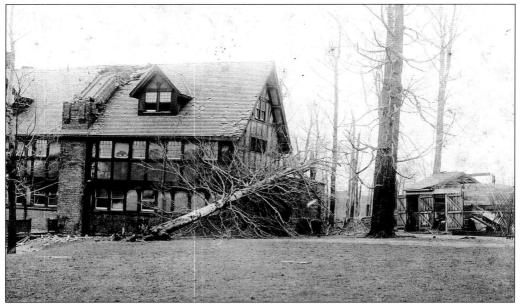

EUCLID CLUB HOUSE, 1909. Located approximately at Norfolk and Derbyshire Roads, the club house and golf course, which extended south across Fairmount Boulevard, were built in 1901 by Calhoun to attract residents to his allotment. The photograph shows the destructive impact of a "young tornado." The club was disbanded in 1913, making way for the Euclid Golf allotment. (WRHS.)

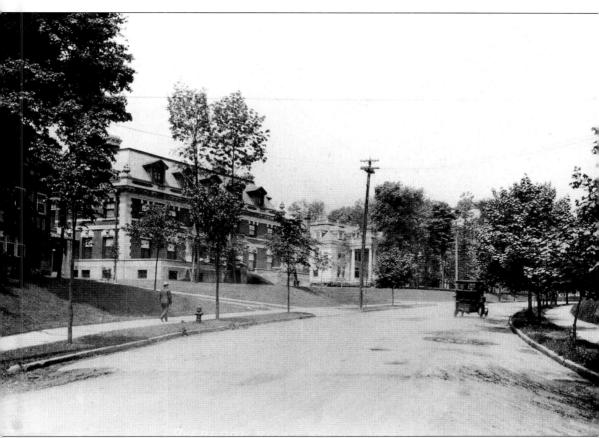

OVERLOOK ROAD, LOOKING NORTH, C. 1905. Here is "The Overlook" in its heyday, lined with grand mansions that rivaled those on Euclid Avenue. On the near left are the homes of Hermon Kelley (1898); Loftus Cuddy (1902); Samuel Dodge (1904); and barely visible through the trees, John Sherwin (1905). Their neighbors included other wealthy entrepreneurs, bankers, and lawyers. The most prominent resident of "The Overlook" was Republican politico, Myron T. Herrick, who served on Cleveland City Council (1885–1890), as governor of Ohio (1903–1905), and ambassador to France during the presidencies of Ohioans William Howard Taft and Warren G. Harding. Herrick Mews is named for him. (WRHS.)

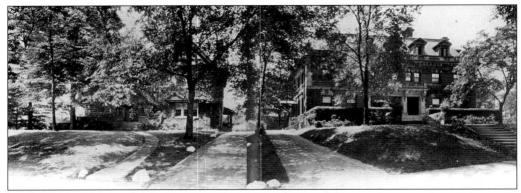

URSULINE COLLEGE, 1930. The Kelley and Cuddy homes seen in the preceding photograph were purchased in 1927 by Ursuline College. The Tudor-style Kelley home at 2244 Overlook became the college library, Beaumont Hall, and the Cuddy mansion at 2234 Overlook, designed by Milton Dyer, became the classroom and administration building, Merici Hall. These purchases initiated the transformation of "The Overlook" from mansions to institutions that would continue in the next decades. (Ursuline College.)

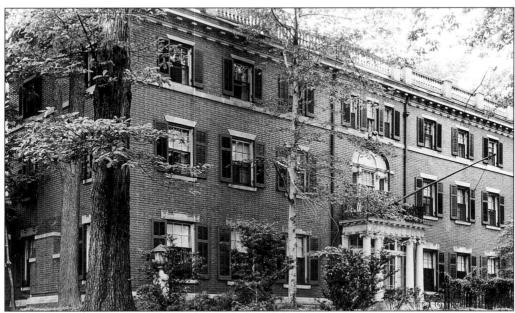

JOHN SHERWIN MANSION. In 1944, Ursuline College purchased this very imposing neoclassical revival mansion at 2214 Overlook for a dormitory. Ursuline moved to its current Pepper Pike campus in 1959. In the 1960s, the college buildings and several homes on Carlton Road were demolished and replaced by the dormitories, fraternity houses, tennis courts, and park built by Case Institute of Technology (now Case Western Reserve University). (Ursuline College.)

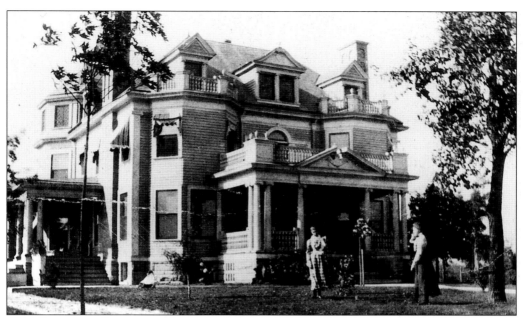

2708 BERKSHIRE ROAD, C. 1910. Early Euclid Heights homes east of the Overlook mansions, like this residence of G.P. Comey, often expressed the Victorian conviction that more decorative detail is more beautiful than less. Note the three porches, several gables, asymmetrical facade, and elaborate spindlework. On this large lot now sit two smaller homes. (WRHS.)

BRIGGS ESTATE, 1928. The largest single estate in Euclid Heights was completed in 1906 and designed by Charles Schweinfurth for Dr. Charles Edwin Briggs. This photograph by Margaret Bourke-White appeared in *Town and Country Club News*, which often featured the residences of affluent suburbanites. Bourke-White photographed other Cleveland Heights homes and gardens, including those of Elisabeth Severance Prentiss Allen, before establishing her career as a war correspondent and photojournalist for *Life* magazine. In 1965, the Briggs' estate became the site of the city's first condominiums. (WRHS.)

ST. ALBAN CHURCH, 1942. This first church in the Euclid Heights allotment was originally named St. Andrews; its Gothic architecture reflected the English origins of the Episcopalian denomination. This service honored those members of the congregation who served in World War II. (Cleveland Public Library.)

FIRST ENGLISH LUTHERAN CHURCH, 1951. This English-speaking congregation was founded in 1881 as the Evangelical Lutheran Church of the Holy Trinity of Cleveland and in 1905 changed its name to First English Lutheran Church. The cornerstone of this Gothic stone structure at Euclid Heights and Derbyshire was laid in 1933, but because the congregation's funds were impounded in a failed bank, the building was not complete enough to use until 1938. An education wing was added to the west of this building in 1961. In 2002, the congregation voted to disband and distribute its financial assets to charitable agencies that it had long supported. (Sue Hanson.)

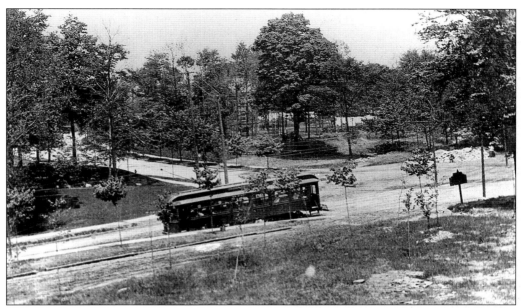

STREETCAR AT EUCLID HEIGHTS AND OVERLOOK. The streetcar so necessary for the development of Calhoun's Euclid Heights had within decades made the suburb more accessible and less exclusive. For example, the huge mansion of Howard P. Eells, visible between the trees in the center of the photograph, was replaced by an apartment building in 1951. (CHPDD.)

EUCLID HEIGHTS BOULEVARD APARTMENTS. The streetcar ran east along Euclid Heights, and its north side became lined with imposing apartments during the 1910s and 1920s. Developers also built grand apartments on Overlook, east of the allotment's first mansions. (Marian J. Morton.)

J.P. Preyer Home. Preyer owned much of the property west of Superior that became the Mayfield Heights allotment of Marcus M. Brown. Preyer was also the proprietor of the Lake View Wine Farm in what is now Cumberland Park. This home, reputedly the oldest structure in Cleveland Heights and a designated landmark, was built in 1825 and remodeled about 1900. (Special Collections, Cleveland State University.)

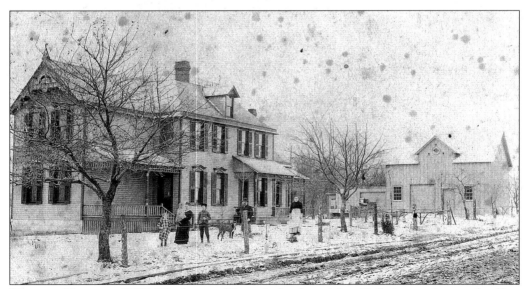

Hellwig Home, c. 1882. The home of Preyer's daughter, Mary Hellwig, was just south of her father's home on unpaved, muddy Superior Road. Neither the gracious Victorian farm house nor the large barn has survived. (CHPDD.)

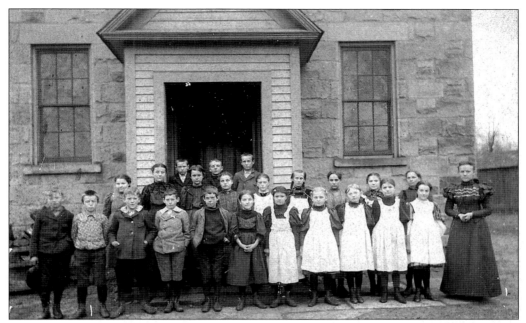

SUPERIOR SCHOOLHOUSE, C. 1891. Students and teacher posed in front of this one-room schoolhouse on Superior. East Cleveland Township built this structure in about 1860, which was rebuilt or faced with local stone in 1882. A second floor was added in the 1890s. Children went here through grade six and then attended Shaw High School. Cleveland Heights built its own high school in 1903. The schoolhouse is listed on the National Register of Historic Places and is a designated Cleveland Heights landmark. (CHPDD.)

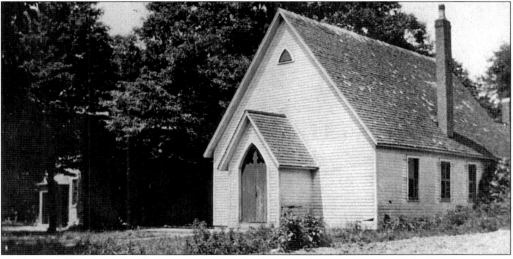

FAIRMOUNT METHODIST EPISCOPAL CHURCH. This modest structure, built in 1878 next door to the schoolhouse, was the second home of this congregation, which had originally worshiped in the schoolhouse itself, seen at the left. The congregation was founded in 1875 when this area was known as Heathen Heights "because of the boisterous conduct during the evening hours by many of the stone quarry workers living nearby," according to the congregation's history, *Church of the Saviour*. (Church of the Saviour.)

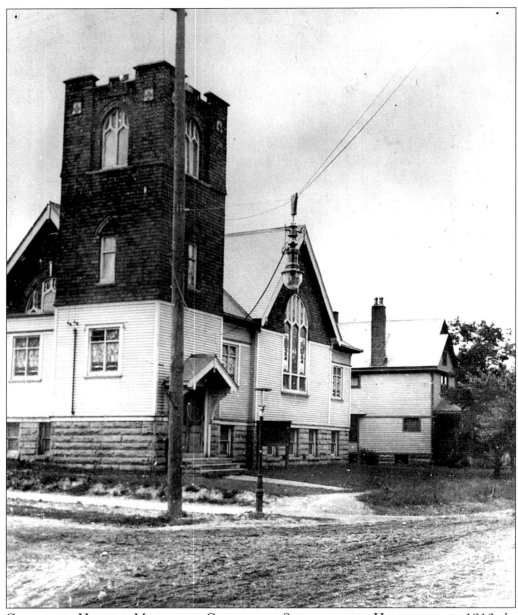

CLEVELAND HEIGHTS METHODIST CHURCH AT SUPERIOR AND HAMPSHIRE, C. 1910. In 1904, Fairmount Methodist Episcopal Church changed its name, moved north on Superior, and built this Gothic Revival structure designed by Sidney R. Badgley, the architect for Cleveland Heights Presbyterian Church and several Cleveland churches, including Pilgrim United Church of Christ. This building has survived as the city's oldest house of worship. Its stained glass windows bear the names of its founding members. The Methodist congregation sold the building to the Church of the Brethren, and after worshiping for four years in Roosevelt Junior High School, completed its current home on Lee Road in 1928 and became Church of the Saviour. (Church of the Saviour.)

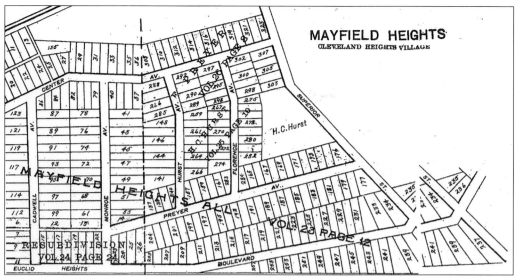

MAYFIELD HEIGHTS ALLOTMENT, 1903. In 1896, Marcus M. Brown purchased the Preyer property west of Superior for this allotment. Preyer, Florence, Hurst, and Monroe Avenues later became Somerton, Radnor, Middlehurst, and Wilton Roads, respectively. The nearby school and church made the allotment attractive to new suburbanites. (Cuyahoga County Archives.)

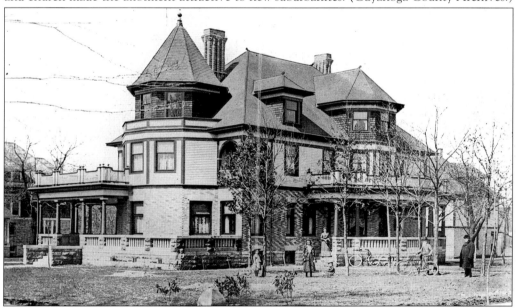

MARCUS M. BROWN HOME, C. 1900. The earliest homes in the allotment were larger than those in Cedar Heights, less grand than the urban mansions on Overlook, but still very substantial. Their wide porches and windows welcomed the outdoors and the natural landscape. Like Calhoun, Brown, seen here with his family, ran into financial difficulties. In 1907, Brown put his home on the market "to satisfy a mortgage held by the Cleveland Trust Company." Brown asked $25,000 for this home with "15 large rooms and billiard room, finished in mahogany, cherry, and quartered oak." The bank foreclosed on the allotment in 1908, and the home was still unsold when Brown died in 1909. (WRHS.)

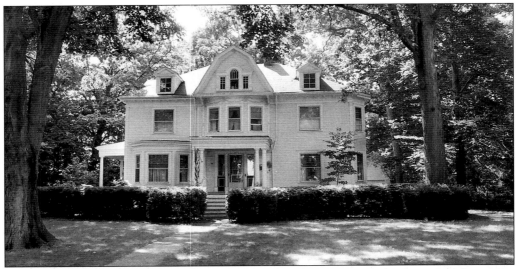

"Country Home" on Cadwell. Brown's early advertising urged prospective buyers to abandon the city for the trees and lawns of spacious suburban homes like this: "Nothing can be more restful from the grind and wear of business life in a great city than this . . . country home." The advertisement also boasted of these "thrifty, intelligent, and worthy" new residents: "Dr. Wm. Gifford, Practicing Physician; George F. Hammond, The Architect," and several other professionals and businessmen. (James W. Garrett IV.)

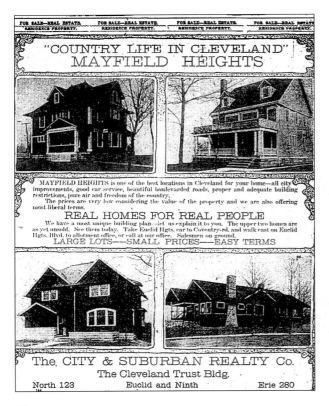

"Real Homes for Real People." Brown's creditors advertised the development aggressively to a different market than Brown had first sought, although the development's suburban charms were still emphasized: "Mayfield Heights is one of the best locations in Cleveland for your home—all city improvements, good [street]car service, beautiful boulevarded roads . . . pure air and freedom of the country. . . . The prices are very low considering the value of the property and we are also offering most liberal terms." (CHPDD.)

"COLONIAL HOME ON EUCLID BOULEVARD," 1910. This gracious home was advertised as having "[T]en rooms and large halls; hardwood floors throughout; living room finished in solid mahogany; dining room white enamel. . . . 3rd floor has bath, two sleeping rooms and billiard or ballroom; red tile roof; price is $11,500." (James W. Garrett IV.)

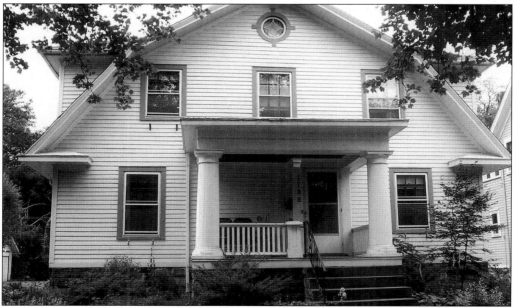

"COTTAGE HOME, RADNOR ROAD," 1910. This was a more modest home: "Seven rooms, electric lights; all modern conveniences, hardwood floors; . . . near car line; price $5,000; easy terms." A bonus: Mayor Frank C. Cain lived across the street. (James W. Garrett IV.)

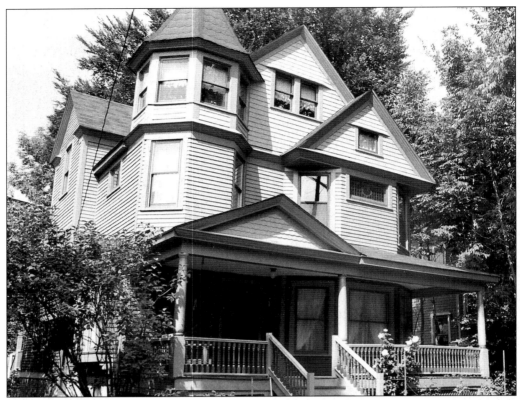

HAMPSHIRE VICTORIAN. This home, built in 1900, with its tower, front-facing gables, and wide porch, resembles homes in Cedar Heights. These are more reminiscent of the late nineteenth-century city than early twentieth-century suburbia. (James W. Garrett IV.)

MIDDLEHURST NEIGHBORS. Block parties are a Cleveland Heights tradition and help to knit together diverse neighbors. Costumes and make-up make this annual event on Middlehurst as unique as the homes in the Mayfield Heights neighborhood. (Roy Woda.)

EMIL C. PREYER HOME. Emil C. Preyer built this gracious colonial on Superior next to the home of his father, J.P. Preyer. The younger Preyer laid out two streets on the site of his family's vineyards east of Superior. (James W. Garrett IV.)

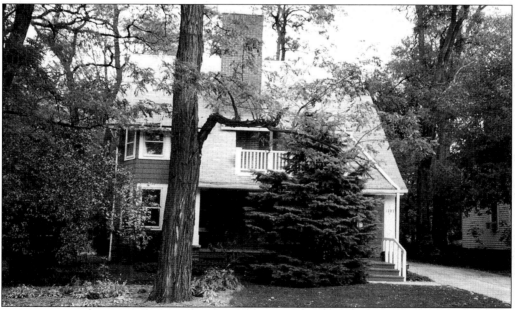

PREYER ROAD. Initially named "Alvin," this street of modest single and double homes is now named Preyer after its owner and developer. A second street, "Brunswick," appears on a 1914 plat map just to the east of Alvin. Brunswick was never developed, however, because in 1916, Cleveland Heights bought the property for Cumberland Park and Pool. Landscape architect A.D. Taylor designed the park. (James W. Garrett IV.)

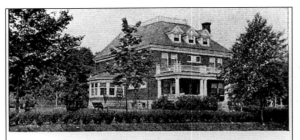

REST HAVEN
The Sanitarium on the Heights, Inc.

A Private Sanitarium for nervous and chronic cases and for patients who are recuperating or seek a needed rest. The aged folks who desire a permanent home will receive the best of care here.

REST HAVEN "*The Sanitarium on the Heights*" situated on Superior Road, just south of Mayfield Road, is a large private residence, set in the center of beautiful grounds. Accommodations for eight only.

REST HAVEN is under the care and supervision of Mrs. Anna Schmitt, whose many years of practice as a trained nurse and sanitarium matron qualify her to know exactly what to do for those placed in her care.

REST HAVEN is conveniently located, being quite near Cleveland, Shaker Heights and East Cleveland. Large airy rooms, all elaborately furnished in delightful color schemes.

We will be glad to show you our rooms at any time.

Reservations Accepted for Advanced Dates

REST HAVEN
"The Sanitarium on the Heights, Inc."

14274 Superior Road Fairmount 7973

REST HAVEN, 14274 SUPERIOR ROAD, 1927. The fresh air of this neighborhood was thought to benefit not only home-buyers but "nervous and chronic cases and . . . patients who are recuperating or seek a needed rest" at this "Sanitarium on the Heights." The structure was built in 1909 as the home of Moritz Stone and was later purchased from the sanitarium and remodeled by the Heights Orthodox Congregation. (WRHS.)

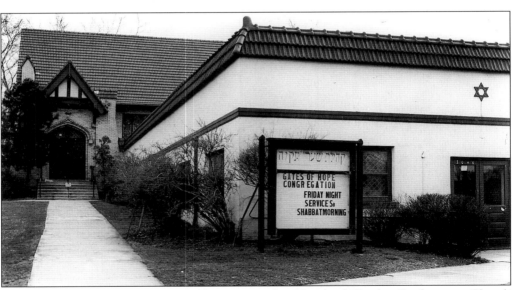

GATES OF HOPE (SHAAREY TIKVAH). In 1909, the Cleveland Heights Presbyterian Church dedicated this structure at 3040 Mayfield at the end of Preyer, designed by Badgley and Nichols. In 1950, the building was sold to this Jewish congregation. The location was close to other Jewish institutions: the Heights Orthodox Congregation, the Montefiore Home, and the Temple on the Heights (B'nai Jeshurun). The Presbyterians moved across the street and became Forest Hill Presbyterian Church. In 1970, Shaarey Tikvah sold this property to Jaguar Cleveland and moved to Beachwood. (WRHS.)

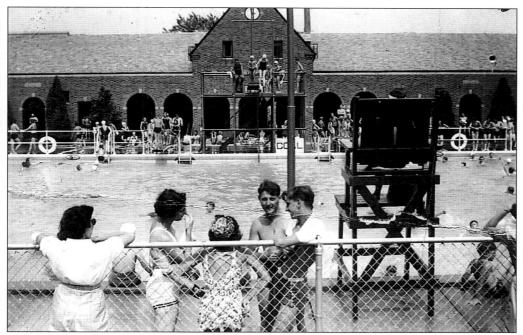

CUMBERLAND POOL, 1937. Designed by William Robert Purcell, the Williamsburg Georgian bathhouse was completed in 1927. The pool, complete with a very high diving board, became a popular and crowded place on hot summer days. "We lived at Cumberland Pool in the summers. I think it was ten cents a day," recalled Edward H. Frost in 2002. (CHPDD.)

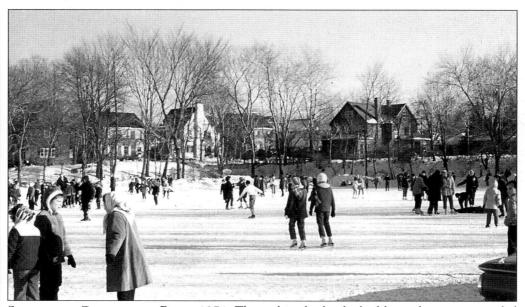

SKATING AT CUMBERLAND PARK, 1971. The parking lot by the bathhouse became a crowded ice rink during Cleveland's long winter. Cleveland Heights residents now skate year-round at two indoor rinks at the Community Center. (CHPDD.)

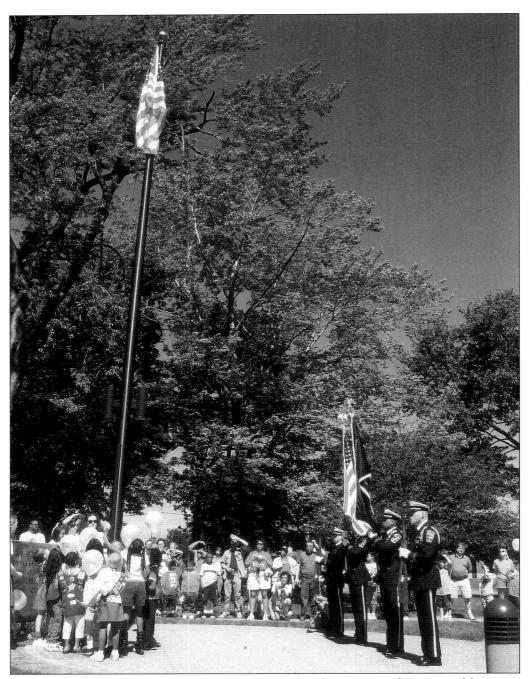

MEMORIAL DAY AT CUMBERLAND PARK, 2002. After the creation of a memorial honoring Cleveland Heights residents who served in the Korean, Vietnam, and (first) Gulf Wars, Memorial Day ceremonies were held at this northern end of the park, near the World War II Memorial. Twelve Cleveland Heights residents died in the Korean War and eleven in Vietnam. On this Memorial Day, an honor guard watched as the Girl Scouts raised the flag. (Community Relations Department, City of Cleveland Heights.)

34

Two
STREETCAR SUBURB
VARIATIONS ON SUBURBAN THEMES
1910–1930

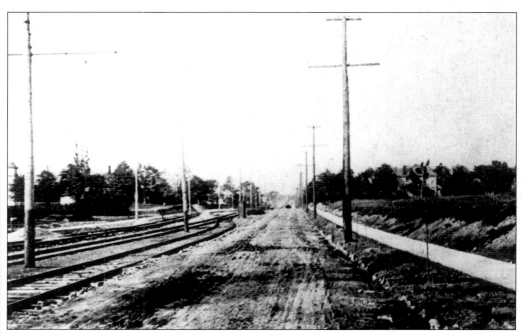

MAYFIELD AND LEE ROADS, C. 1900. The electric streetcar lines stretched east on Mayfield along the tracks of the inter-urban train that earlier had carried commuters from Cleveland to Gates Mills. The extension of streetcars on Mayfield, Fairmount, and Cedar spurred residential development, and in the next decades, suburban housing in many styles replaced farms, orchards, quarries, and farmhouses. (WRHS.)

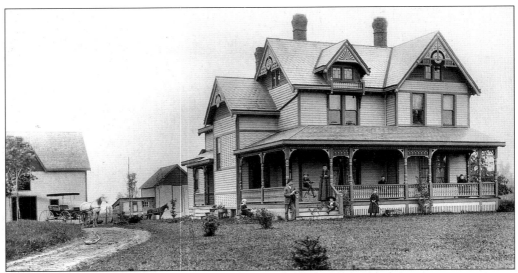

O.A. Dean Home and Dairy on Mayfield, c. 1900. This imposing Victorian farmhouse was located at 3151 Mayfield Road, later the site of the Montefiore Home and now the site of Homewood at Rockefeller Gardens. The family, seen here on the wraparound porch, operated the dairy in the barns and fields of this still-rural setting. Three decades later, resident Mary J. Lawrence remembered "the old farmhouse with its spacious rooms and wide lawn [as] an ideal center for socials." (CHPDD.)

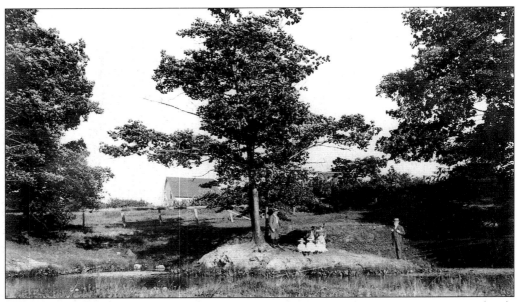

Severance Family Farm on Mayfield, c. 1900. Members of the Severance family purchased large parcels of property at Mayfield and Taylor in the 1890s. At the northeast corner of the intersection lived Dr. Benjamin L. Millikin and his wife Julia Severance, and immediately to the east, Dr. Dudley P. Allen and his wife, Elisabeth Severance, daughter of Louis Henry Severance and cousin of Julia Severance Millikin. The Allen and Millikin families lived on Euclid Avenue and used these properties for their summer residences. (WRHS.)

GLEN ALLEN GARDEN, 1916. In 1915, Elisabeth Severance Allen, recently widowed, made the Mayfield estate her permanent residence and named it Glen Allen. She commissioned Charles Schweinfurth, the architect of many Euclid Avenue mansions, to build her home seen in the background, and turned the pastures into formal gardens. In 1917, Elisabeth Severance Allen married Francis Fleury Prentiss. She was a significant benefactor of many institutions, including the Cleveland Museum of Art, Case Western Reserve University, and St. Luke's Hospital. (WRHS.)

GLEN ALLEN, 1928. This photograph by Clifford Norton illustrates the dramatic use of stone and glass characteristic of Schweinfurth's work. Glen Allen was demolished in 1945 after Elisabeth Severance Allen Prentiss's death. Part of the property was developed as Glen Allen Drive and Birchtree Path. On the portion of the property facing Mayfield were built the Jewish Community Center and Lutheran East High School. The stone wall of the estate remains. (WRHS.)

BEN BRAE, 1932. When Dr. Benjamin Millikin and his wife, Julia Severance, made their permanent home in Cleveland Heights in 1913, they built this Tudor revival home, Ben Brae. Although imposing, this was less formal than its neighbor, Glen Allen. (WRHS.)

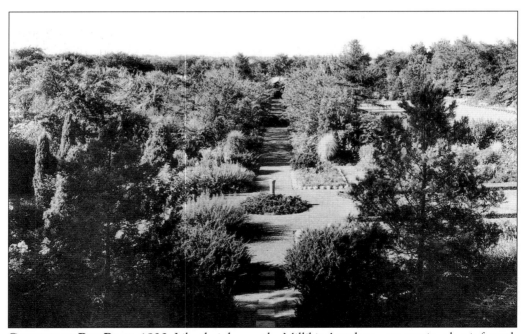

GARDENS OF BEN BRAE, 1932. Like their home, the Millikins' gardens were spacious but informal. This view looks north toward Lake Erie, which was probably visible. Ben Brae was demolished in 1953. On its site is a fire station. Part of the original stone wall remains. (WRHS.)

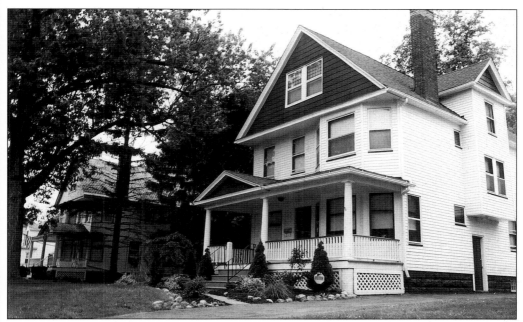

MAPLE ROAD. Just to the east of the Severance homes, small developments like Crestwood, Parkhill, and Maple Villa had already taken shape along the Mayfield inter-urban line. In 1914, however, there were only three houses on Maple, although there were several on Crest Road. These early homes, like those in Cedar Heights, often had wide gables and porches that faced the street and their neighbors. (James W. Garrett IV.)

MIDDLETON ROAD BUNGALOWS. In 1905, the Bingham Jackson Company assured prospective buyers that its Maple Villa allotment, which included Middleton at Stop 6 on the Cleveland & Eastern interurban line, was only 45 minutes from Public Square: "On a clear day the lake shows very plain." Immediately to the south was the Oakwood Club, founded in 1905, the Jewish response to Calhoun's Euclid Club. (Marian J. Morton.)

COMPTON HEIGHTS. To the west of Taylor along Mayfield and the inter-urban tracks, Beachland Realty developed Compton Road, originally the property of Charles W. Compton, an early resident of East Cleveland Township. Here is the realtor's description in 1907: "Compton Road is the most beautifully situated of any street in the Mayfield section. The view of Lake Erie is sublime. . . . [N]o business blocks; no cheap neighbors; no undesirable surroundings." Little wonder that in 1921, long-time mayor Frank C. Cain chose Compton on which to build his brick colonial home, seen here in the distance. (Marian J. Morton.)

COMPTON NEIGHBORS, 1996. Like Cain, Compton residents have been enthusiastic players in the suburb's civic life. Their float participated in the parade celebrating Cleveland Heights' 75 years as a city. (Susie Kaeser.)

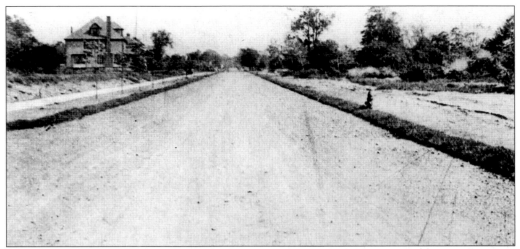

LEE AND WHITEHORN, C. 1910. In 1890, long-time resident James Haycox, owner of substantial property east and west of Lee and south of Superior, and Charles Asa Post, businessman and historian, bought a 40-acre farm at Lee and Mayfield. Post later described the farm as "very beautiful in the spring and summer [with] trees, which loaded the air with their wonderful perfume." The developers laid out streets named after those trees: Oak, Sycamore, and Whitethorn. To make their development more accessible, Haycox and Post persuaded the Cleveland Electric Railway to run a streetcar line up Mayfield to Lee. They also extended Lee from Mayfield to Euclid Heights Boulevard, but as seen here, houses were few and far between in this development until the end of the 1910s. (WRHS.)

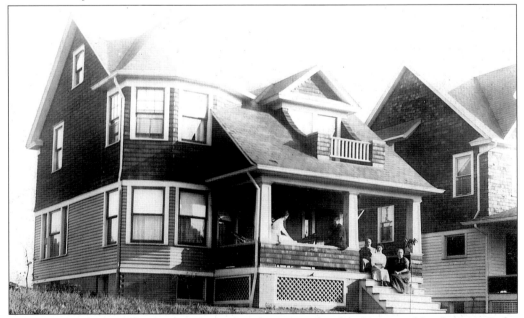

FRONT PORCH ON OAK, 1910S. The earliest homes in this development, like those in Cedar Heights, Mayfield Heights, and the developments along Mayfield, boasted wide front porches, generous windows, and sometimes a Victorian tower. Posed here is the family of Betty Dean Calhoun. (Ken Goldberg.)

LEE SCHOOL, C. 1920. Haycox and Post sold some of their property to the Cleveland Heights school district, and it became the site of this elementary school, which opened in 1902 with 125 students, four teachers, and a principal. Teachers then earned $50 a month; the principal earned $80. (CHPDD.)

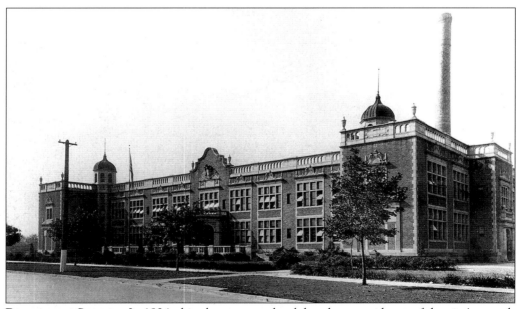

BOULEVARD SCHOOL. In 1924, this elementary school, handsome evidence of the city's growth and affluence, replaced Lee School. The first high school was also on this site at Lee and Euclid Heights. (Cleveland Heights-University Heights Board of Education.)

Sycamore Road. In 2002, Edward H. Frost recalled growing up on Sycamore during the 1930s: "there were 72 kids on the street . . . and it was just a wonderful street and community. Sycamore Road had its great Fourth of July celebrations . . . and [they] went on all day long and you had prizes for the best decorated house and the north side played the south side." At those Fourth of July celebrations, Sycamore homes, flags flying on wide porches, probably looked much like they do here. (James W. Garrett IV.)

Grant W. Deming, c. 1918. The creator of the (first) Forest Hill, Hyde Park, and Minor Heights allotments, Deming is pictured here at the foot of the front porch of his Redwood Road home, built in 1909. These allotments could be reached by either the Euclid Heights or the Mayfield streetcar—and a hike. Recently designated a Cleveland Heights landmark, this shingle-style home resembles some of the first homes built in Deming's Forest Hill and Hyde Park subdivisions. (CHPDD.)

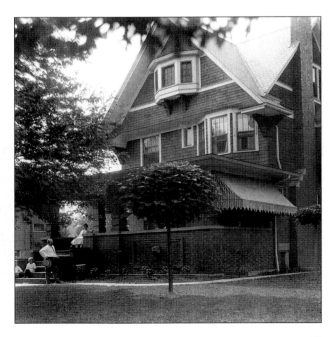

LINCOLN BOULEVARD. Around the corner from Deming's home, this colonial revival was in his Forest Hill allotment, bounded roughly by Euclid Heights Boulevard and Lee and Cedar Roads. Much of the property had belonged to James Haycox. In 1909, Deming's advertisement for the allotment praised "its high elevation, pure healthful air, commanding view, luxuriant shade, boulevards and grassy plots." (James W. Garrett IV.)

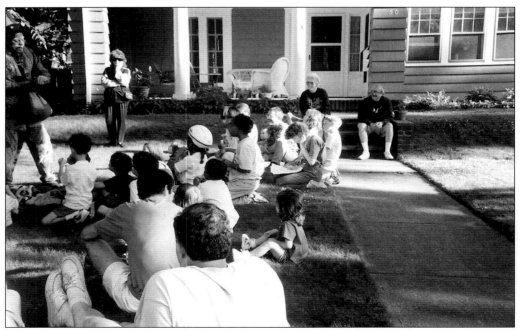

EAST OVERLOOK BLOCK PARTY, 1999. A decades-long tradition on this street in the Forest Hill allotment, this celebration featured the clown at the left as a special treat for children and grownups. (Marie Salkin.)

MINOR FARM HOUSE, SOUTH TAYLOR ROAD. South Taylor was first named Minor Road after the Seth and Marion Minor families who owned much of the property on both sides of the street. Some of these acres west of Taylor Road were developed by Grant W. Deming for an allotment called Minor Heights: Beechwood, DeSota, Altamont, and Berkeley Roads. (CHPDD.)

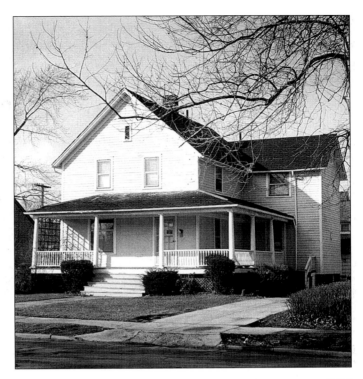

MAKING HAY AT ALTAMONT, C. 1910. Horse-drawn machinery cleared the fields of the Minor farm where Deming would soon lay out Minor Heights. Seth Minor's daughter, Stella Minor Antisdale, later recalled her youth on the farm: "When the haying was done . . . Father would fasten the hayrope to a high beam, and how we did swing!" Antisdale and Blanche Roads are named for Minor's daughters, Stella Minor Antisdale and Blanche Minor Taylor. Minor Park Road also bears the name of the early property owner. (WRHS.)

HYDE PARK AVENUE BUNGALOW. Popular choices for suburbanites in the 1910s, bungalows were a perfect fit for smaller lots and families. The several bungalows on Hyde Park display Deming's imaginative use of varying architectural styles to attract as wide a market as possible. In order to persuade city-dwellers to move this far east, Deming's advertisements also emphasized that his developments were close to the schools on Lee Road and the Methodist and Presbyterian churches in Mayfield Heights. (Marian J. Morton.)

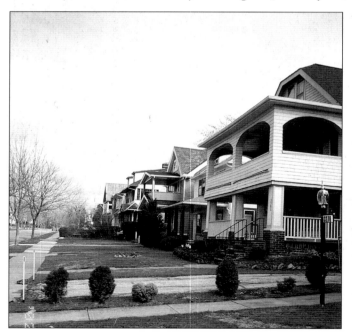

DESOTA DOUBLES. Minor Heights featured comfortable double homes, often "Cleveland doubles" like these, with broad front porches and identical first and second floors. This development was intended for a different market than the Hyde Park and Forest Hill allotments, 0but was also close to the Mayfield streetcar. (Marian J. Morton.)

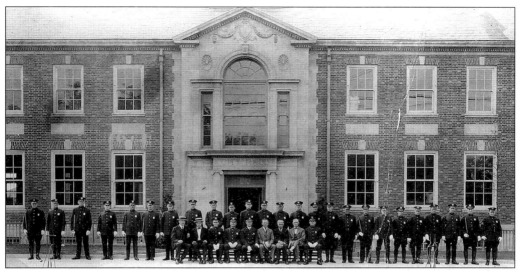

CITY HALL, 1924. Police and members of Cleveland Heights council posed for this photograph in front of the new city hall at Mayfield and Superior. The colonial revival structure with its detailed facade and entrance was designed by William R. Powell, also the architect of Cain's Compton Road house and the Cumberland Pool bath house. (CHPDD.)

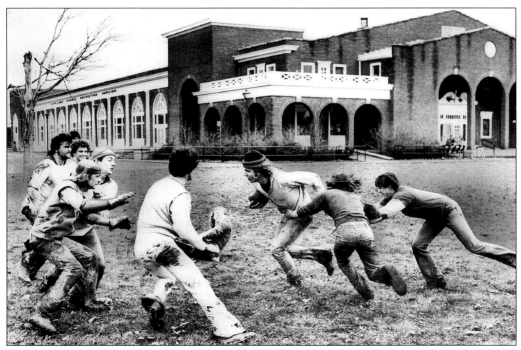

RECREATION PAVILION, 1980. Mayfield Road remained the center of much of the community's public life. The city opened this pavilion in 1969 east of city hall and across from the Mayfield entrance to Cumberland Park. These young men were playing football on a winter morning just to the south of the pavilion, which was also done in the colonial style. (Photograph by Tony Tomsic, Special Collections, Cleveland State University.)

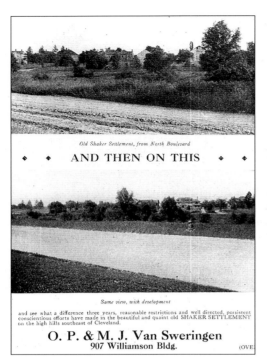

Old Shaker Settlement, from North Boulevard

✦ ✦ AND THEN ON THIS ✦ ✦

Same view, with development

and see what a difference three years, reasonable restrictions and well directed, persistent conscientious efforts have made in the beautiful and quaint old SHAKER SETTLEMENT on the high hills southeast of Cleveland.

O. P. & M. J. Van Sweringen
907 Williamson Bldg. (OVE)

SHAKER HEIGHTS VILLAGE, 1911. The south side of Cleveland Heights also developed along a streetcar, the Fairmount Boulevard line. M.J. and O.P. Van Sweringen had persuaded the trustees of Cleveland Heights to allow the Cleveland Railway Company to extend its line east on Fairmount to Lee Road. The brothers began their successful careers as real estate entrepreneurs by developing the former North Union Shaker community, "the Valley of God's Pleasure," on the lower Shaker Lake. This advertisement in the *Cleveland Blue Book* boasted of progress: the grand home and paved road (North Park Boulevard) had replaced the old Shaker mills and farmhouses. (WRHS.)

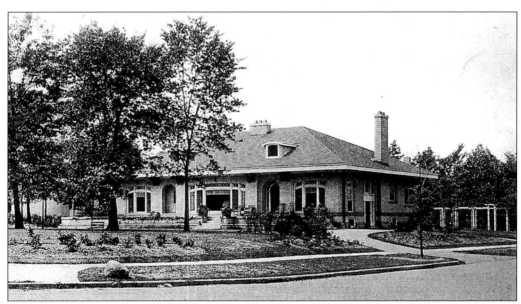

STRATFORD ROAD, 1917. Shaker Village included Fairmount from Coventry to Lee Roads, as well as the north-south streets of Fairfax, Arlington, Wellington, Guilford, and Stratford Roads. The developers allowed styles that ranged from traditional colonials to this ambitious bungalow of J.C. Beardslee. All homes had to be architect-designed, however. The brothers applied even more exacting standards in their later development of the suburb of Shaker Heights. (Special Collections, Case Western Reserve University.)

Four Fairmount Boulevard Homes Make Artistic City Block

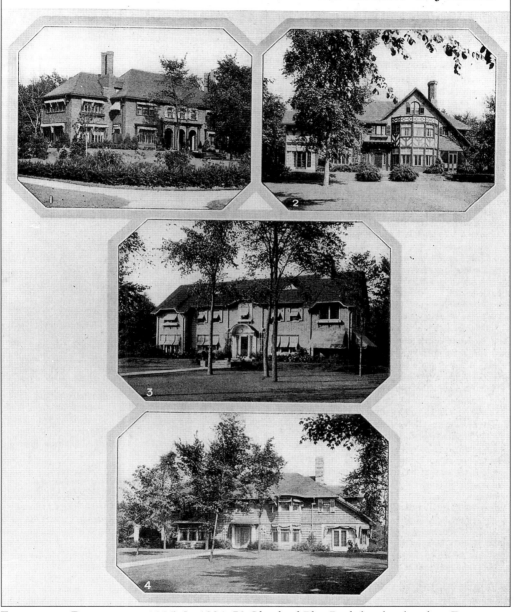

FAIRMOUNT BOULEVARD, 1925. In 1924, 70 *Cleveland Blue Book* families lived on Fairmount. Magazines like *Town and Country Club News* often featured photographs of distinguished suburban homes like these designed by Meade and Hamilton. From 1911 to 1940, Meade and Hamilton also designed many homes in the Euclid Heights and Ambler Heights developments in the wide range of styles illustrated here. (WRHS.)

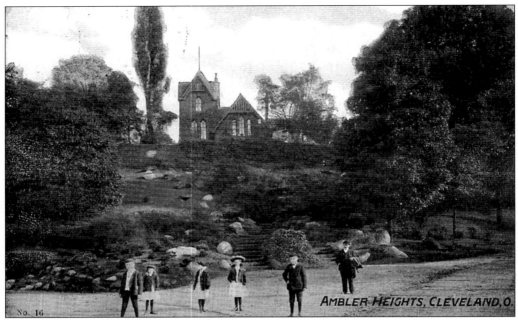

ROCK REST. This postcard featured the imposing home built by Dr. Nathan Ambler just east of the current site of the Baldwin Filtration Plant on Fairhill Road. Ambler and then his adopted son, Daniel O. Caswell, operated the Blue Rock Spring House, a water cure resort at the foot of Cedar Glen just south of University Circle, until 1908. (CHPDD.)

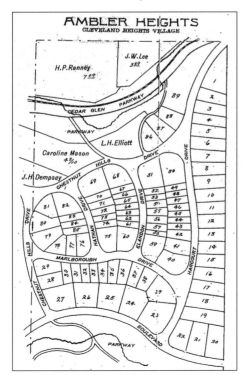

AMBLER HEIGHTS, 1903. Ambler also owned property between his home on Fairhill (then called Fairmount) and Cedar Glen that Caswell began to develop in the 1890s as Ambler Heights. The Euclid Heights streetcar made this development, just south of Calhoun's, easy to reach. This map shows the curving streets and large, irregularly shaped lots characteristic of elite suburban developments of this period. Some street names have been changed: Marlborough is now Denton, and Nathan is Devonshire. High on a ridge, the development, now called Chestnut Hills, overlooks the city of Cleveland to its immediate west. (Cuyahoga County Archives.)

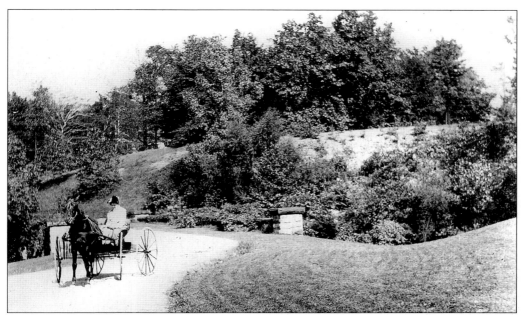

AMBLER PARK, 1903. In 1894, Ambler's widow donated property along Doan Brook to the City of Cleveland for its park system, but this ravine remained a popular place for a fashionable carriage ride and, like the Shaker Lakes, became an asset to the nearby suburban development. (WRHS.)

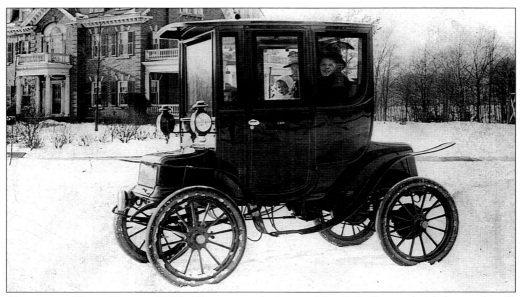

CHESTNUT HILLS DRIVE, 1909. The postcard pictures Mrs. E.B. Brown (with hat and veil) and family in front of their residence designed by architects Meade and Hamilton and completed in 1906. This Baker electric car was long on style and short on power, recalled Mary Louise Brown Curtiss Prescott: "Cedar Hill was a two-lane brick road then. Often a whole line of electrics were stalled on the hill waiting for more juice [electric power], and we would wave at our friends who passed us in motor cars as we waited for juice to build up, and finally 'make' the hill." (Sally C. Fahrenthold.)

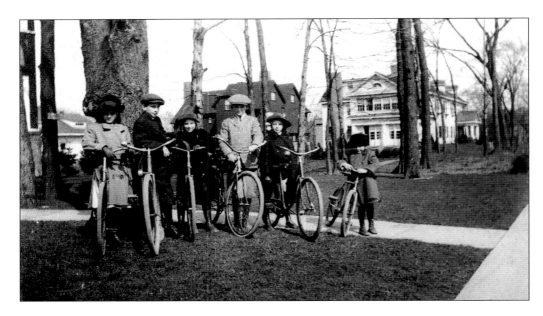

AMBLER HEIGHTS FAMILIES, 1913. During this decade, prominent Cleveland businessmen and professionals bought homes in Ambler Heights. Captured in these engaging snapshots from the C.F. Keim family album is the newness of the development—homes built but landscaping unfinished—as well as the liveliness of its children. Both of these photos were taken from the Keim home on Elandon Drive: the one on the top looks north, and the lower photograph looks directly across the street. Mary Louise Brown Curtiss Prescott's memoirs describe her childhood in this neighborhood: "We knew who lived in every house and often held neighborhood affairs. All the children would go Halloweening together, hold a fair together, give plays together, or have boy and girl wars together." (WRHS.)

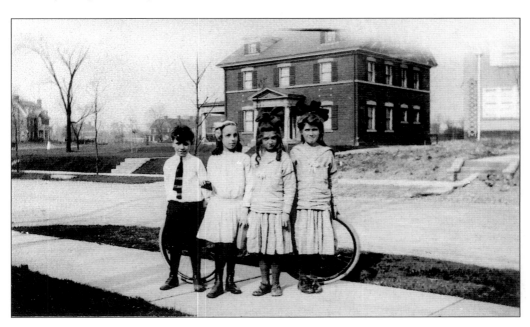

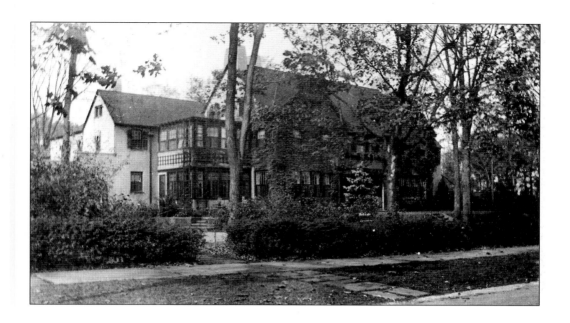

DEVONSHIRE DRIVE HOMES, 1919. These snapshots are also from the Keim family album; underneath the photographs of two of the allotment's distinguished homes, someone has noted their owners. Architectural firms including Meade and Hamilton, Walker and Weeks, and Howell and Thomas built in the Ambler Park allotment. Like the homes in Shaker Village, these were spacious and intended for affluent but informal living by large families and their servants. (WRHS.)

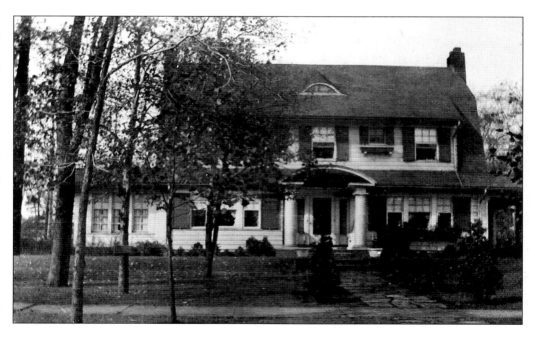

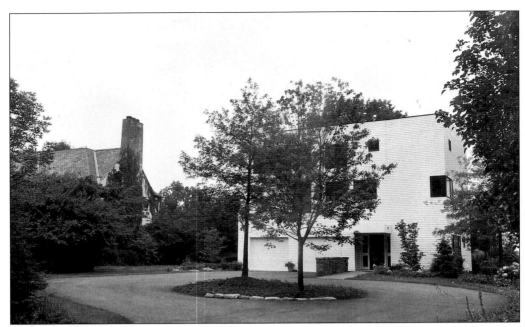

CHESTNUT HILLS, 2004. Contemporary homes like this one continue the eclectic tradition of the allotment's architecture. This neighborhood is listed on the National Register of Historic Places. (James W. Garrett IV.)

DELAWARE DRIVE. Just to the east of Ambler Heights, Jeptha H. Wade Jr. developed Delaware and South Overlook Roads in the 1920s. Better known as a philanthropist and generous donor to the Cleveland Museum of Art, Wade had earlier developed the Wade Park subdivision in University Circle, which includes Wade Park Avenue and Magnolia Drive. (Marian J. Morton.)

Some Euclid Golf Homes

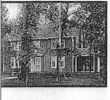

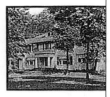

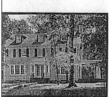
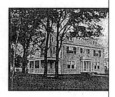

The Euclid Golf Neighborhood

*I*N PURCHASING a home in Euclid Golf you do more than purchase a mere piece of land of great natural beauty, furnished with high grade permanent improvements, and so located as to street car service and general accessibility as to make it the most convenient location for a home in Cleveland. You get all that in Euclid Golf and you get something far more valuable.

You get a share in a neighborhood interest that is expressed in well kept lawns, tastefully treated homes, a general wholesome neighborliness and pride in community that is enthusiastic, spontaneous and sincere. It is this intangible yet noticeable atmosphere of neighborhood interest, which even the stranger feels in driving through the streets that makes Euclid Golf the place where more and more Clevelanders of culture and refinement want to make their homes.

The B. R. Deming Co.

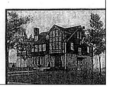

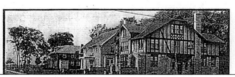

EUCLID GOLF ALLOTMENT. Taking advantage of the streetcar along Fairmount to Shaker Village as well as the failure of Calhoun's Euclid Club, Barton R. Deming, brother of Grant W. Deming, created this development that included Fairmount from Cedar east to Coventry and the north-south streets Ardleigh, Delamere, Tudor, Woodmere, Demington, Chatfield, and St. James Parkway. This neighborhood is also listed on the National Register of Historic Places. (WRHS.)

DEMING HOME, 1917. Deming's own home, pictured top and center in this photograph, was built at the corner of Cedar and Fairmount in 1914 and served as a stunning entrance to the allotment. Designed by Howell and Thomas, the home took advantage of the challenging site overlooking a rocky ravine and a stream, seen here. The man in the photograph may be Deming. (CHPDD.)

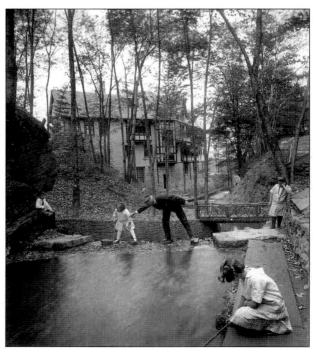

"WILDWOOD," 1917. P.L. Miller, owner of the Miller United Shoe Company, named his Arts and Crafts home on Cedar Road "Wildwood," which probably referred to the dramatic landscape created by the rocky terrain just to the north of the Deming house. Like Deming's home, Wildwood overlooked a stream and pond, probably man-made, which enhanced the home's setting. Wildwood was demolished in 1964. On this site are new town houses. (WRHS.)

DELAMERE DRIVE GARDEN, C. 1920S. Life in the suburbs was intended to bring residents closer to the beauties of nature in a period of rapid, untidy urbanization and industrialization. This intent was reflected in the advertising for developments, such as Mayfield Heights, as well as in the settings of Deming's and Miller's homes. Gardens also brought suburbanites close to nature, although as here, natural beauty was often man-made. Landscape architect A. Donald Grey designed this elegant garden in the Euclid Golf allotment, graced by a poetic young woman. (WRHS.)

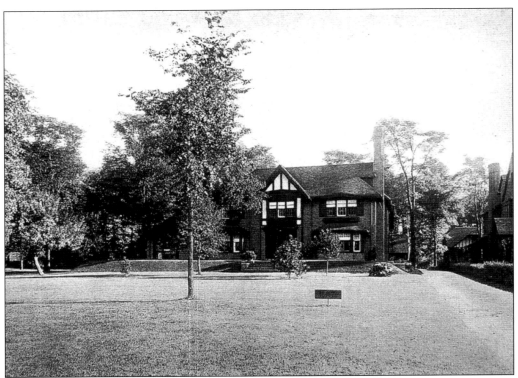

CEDAR ROAD HOME, 1917. Once part of the Euclid Club golf course, although not part of the Euclid Golf allotment, several large mansions, like this home of J.R. Blakeslee, faced Cedar Road. Their wide lawns distanced their owners from the Cedar Road streetcar. (Special Collections, Case Western Reserve University.)

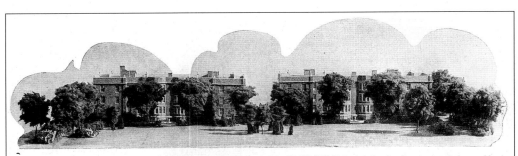

IN Euclid Heights, on part of the delightfully situated site of the former Euclid Golf Club, is being developed an entirely new idea in attractive homes, which might be called the garden group of apartment residences. The property being developed is located on Cedar Road and runs back six hundred feet to Delamere Drive. The basic principle of the whole plan is to combine the unquestioned conveniences of the apartment house with the no less desirable quiet and privacy of home life, eliminating at the same time the drawbacks that are so well known in the average modern apartment and city home. Two of the apartments have been completed as shown in the above photograph. Construction will be started this spring on the third and last of the group, this building facing Delamere Drive. The architecture of the buildings is Georgian, and the residence feature predominates everywhere. Walker and Weeks will be the architects. The greatest care and attention has been given to the planning and development of the gardens and surrounding grounds. They occupy five acres and have been planned by Mr. A. D. Taylor, who is the landscape architect.

For further information regarding the floor plan of suites in the new building, apply to

FRANK C. NEWCOMER Citizens Building

CEDAR ROAD APARTMENTS, 1924. Just to the west of the mansions, these gracious apartment buildings were also built on the former site of the golf course. Walker and Weeks were the architects, and A.D. Taylor designed the five-acre grounds. (WRHS.)

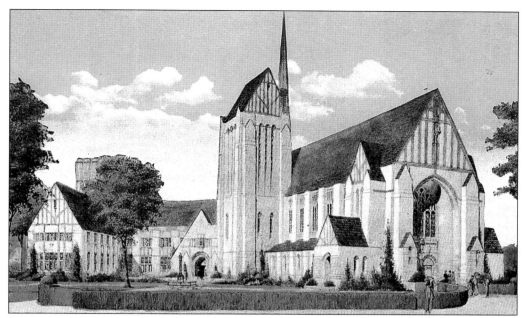

FAIRMOUNT PRESBYTERIAN CHURCH. This congregation first built a wood-frame chapel at the intersection of Fairmount and Coventry in 1915 and held its first service there in 1916. The traditional structure of Ohio sandstone pictured in this postcard is intended to be reminiscent of an English village. This building, dedicated in 1942, has been much enlarged. (CHPDD.)

DEMINGTON ROAD MEMORIAL DAY BLOCK PARTY, 1967. Cleveland Heights block parties are often held on national holidays that give children an opportunity to fly the American flag and ride their bikes in the street. (CHPDD.)

ROXBORO ELEMENTARY SCHOOL, 2004. Roxboro was built at its current location in 1906, and its Georgian colonial structure was completed in 1921 as the Euclid Golf allotment was developed. Both the elementary school and Roxboro Junior High survived the 1970s demolitions of Fairfax, Boulevard, Taylor, and Coventry, and like all the suburb's public schools, now educate children of all races. (Susie Kaeser.)

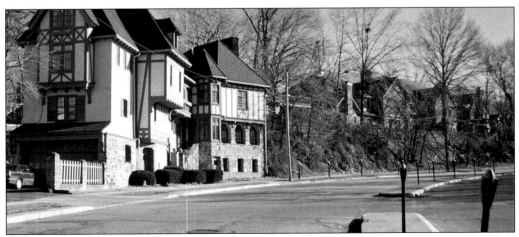

DEMING HOUSE, 2004. The home still provides a dramatic entrance to the Euclid Golf allotment, but new cluster housing has been built immediately to the east. These traditional homes complement the older Fairmount Boulevard homes. (Marian J. Morton.)

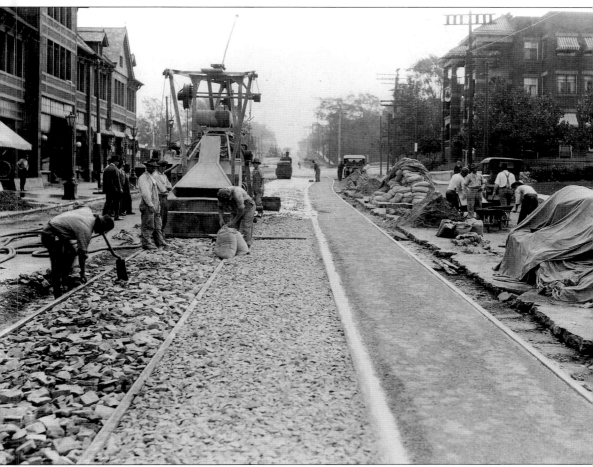

CEDAR ROAD AND SURREY ROADS, C. 1918. This neighborhood was originally part of Calhoun's Euclid Heights, but the deed restrictions prohibiting commerce and multi-family dwellings were removed after Calhoun's bankruptcy. An important shopping and residential neighborhood developed at the intersection of the Fairmount and Cedar streetcar lines. The Cedar streetcar reached Coventry in 1918. On the left is the Heights Center Building, completed in 1916. The apartments on the right were completed in 1912, but were replaced in 1926 by the Fairmount-Cedar Building. (WRHS.)

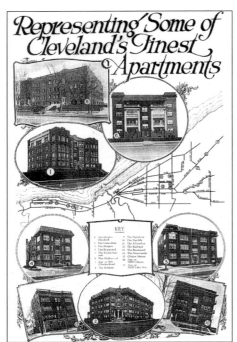

"SOME OF CLEVELAND'S FINEST APARTMENTS," 1923. Four of these apartments were located in the original Euclid Heights allotment: the Heights Overlook on Cedar Road and the Lancashire, the Heights, and the Boulevard on Euclid Heights. The Heights Overlook, 12337 Cedar (designed as number 1 in this photograph) was described by a Cleveland newspaper as "the most exclusive apartment" in Cleveland Heights; residents included a doctor and the employees of leading industries, and the newspaper estimated their annual incomes as between $6,000 and $15,000. (Richard Karberg.)

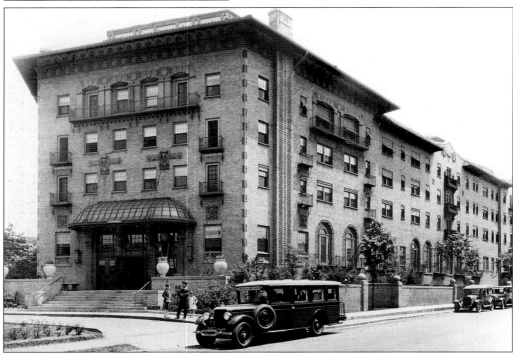

ALCAZAR HOTEL. Cleveland Heights' only hotel, intended for both long-term and transient guests, was built in 1923. Because of its distinctive Mediterranean style, the hotel is listed on the National Register of Historic Places; it is also a designated Cleveland Heights landmark. (CHPDD.)

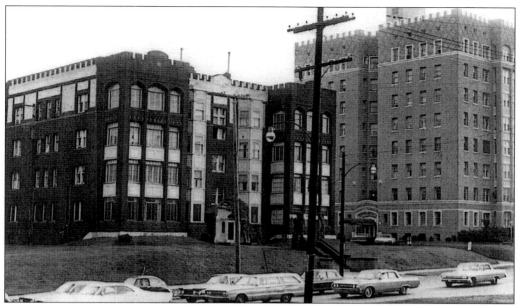

DOCTORS HOSPITAL, C. 1950S. The Cleveland Memorial Medical Foundation purchased the Heights Overlook (left) and the Edgehill (right) Apartments for a general medical and surgical facility that was named Doctors Hospital. The hospital opened in 1946. (CHPDD.)

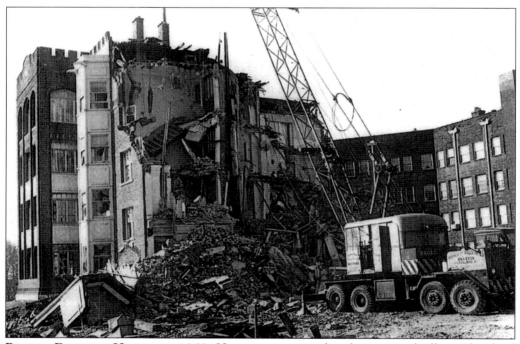

RAZING DOCTORS HOSPITAL, 1969. However, in an early urban renewal effort, Cleveland Heights purchased the two structures and demolished them for a parking lot and a new fire station. The fire station was built elsewhere. Some of the property remains as a park. Doctors Hospital moved east and became Hillcrest Hospital. (CHPDD.)

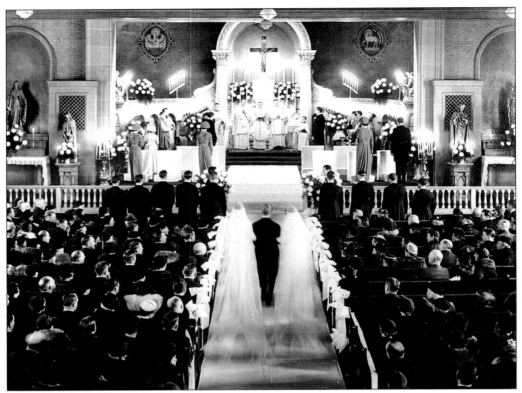

ST. ANN CHURCH, 1935. Father John M. Powers, pastor of St. Ann Church, is often credited with persuading the Cleveland Railway Company to run its tracks farther east to serve his church at Cedar and Coventry. This is the sanctuary of the "old" St. Ann, pre-dating the addition of the sanctuary whose pillared entrance, completed in 1952, faces Coventry. On this occasion, the church and altar were filled for the double wedding of the daughters of a Euclid Heights family. Father Powers, the priest in the center, built St. Ann's recreation hall and rectory in 1915 and the school in 1925. (WRHS.)

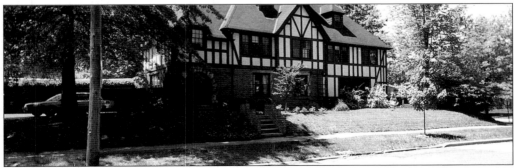

MEADOWBROOK BOULEVARD DOUBLE. According to historian John Starke Bellamy, Father Powers borrowed money from the Cleveland Catholic Diocese to buy the property for the church and adjacent property to be developed by the Meadowbrook Land Company. During the 1920s, doubles like this imposing Tudor revival were built on Meadowbrook in styles compatible with neighboring single-family homes. (Marian J. Morton.)

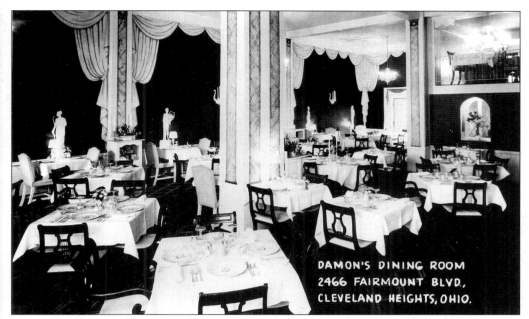

DAMON'S DINING ROOM
2466 FAIRMOUNT BLVD.,
CLEVELAND HEIGHTS, OHIO.

DAMON'S RESTAURANT. Opened by Bertha Damon in the early 1920s at 1846 Coventry, this restaurant was a tenant of the Fairmount-Cedar Building until 1949. This site is now the Mad Greek Restaurant. (WRHS.)

CEDAR-FAIRMOUNT SHOPS, 2004. Appletree Books is one of many small, independently owned shops in this shopping district that grew up at the junction of the Cedar and Fairmount streetcar lines, within walking distance of the single homes and apartments of Cedar Heights, Euclid Heights, and Euclid Golf allotments. (James W. Garrett IV.)

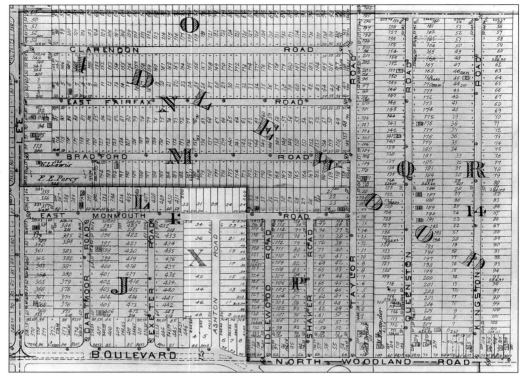

IDLEWOOD VILLAGE, 1912. Originally part of Warrensville Township, Idlewood became an independent entity in 1907. A portion of it—including Clarendon, Bradford, Taylor, Queenston, Kingston, Princeton, and Canterbury Roads—was annexed by Cleveland Heights in 1914. The rest was eventually annexed by University Heights and Shaker Heights. The Cleveland Heights portion was developed as the Fairmount streetcar ran east. (North Woodland Road was renamed Fairmount.) This map also indicates (as small rectangles) the homes that had been built by this date. (WRHS.)

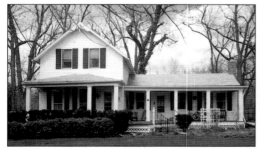
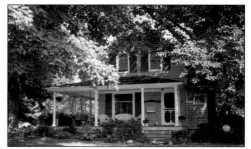

FAIRMOUNT BOULEVARD FARMHOUSES. Both of these Greek revival farmhouses appear on an 1874 atlas of Warrensville Township. Both probably look much today as they did then, and both are designated Cleveland Heights landmarks. The house on the left was built in 1853 for Richard Penty, and the more vertical house with decorative woodwork on the front gable, for John Hecker about 1873. The two family farms were developed in the 1910s as the "royal streets," Queenston, Kingston, and Princeton. (Marian J. Morton.)

KINGSTON ROAD. The Fairmount farmhouses set the tone for this neighborhood, as seen in this front-gabled, broad-porched home. Here, in 1920, lived John L. Anderson, 54; his wife Anna, 46; his two daughters, ages 21 and 19; and his seven-year-old son. Anderson's neighbors were a mix of white-collar and skilled craftsmen, including a bookbinder, a machinist, an accountant, a salesman, and a clerk. (James W. Garrett IV.)

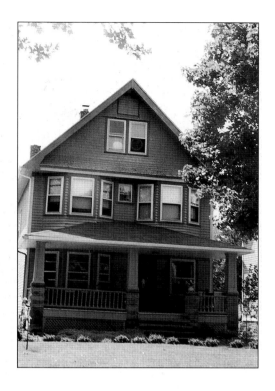

EAST FAIRFAX ROAD DOUBLE. East Fairfax and East Scarborough, like the "royal streets," contain single and double homes like this one. This mixed residential use dates from the beginning of the development and is acknowledged in the 1921 zoning code. (Marian J. Morton.)

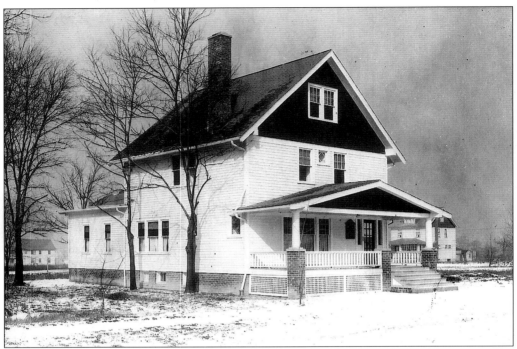

CLEVELAND HEIGHTS EVANGELICAL MISSION, C. 1920. This home on South Taylor Road at the corner of East Scarborough became the parsonage and first assembly place of this congregation of German origin. In 1924, the congregation added a two-story wooden structure just to the north of this building and in 1950, built the brick colonial structure with the steeple that stands on the site today. After two mergers, this is now the Church of the Redeemer, United Methodist. (Church of the Redeemer.)

EAST SCARBOROUGH AND TAYLOR, C. 1920. This view from East Scarborough looks west down its unpaved surface toward Taylor. In the left center is the Cleveland Heights Evangelical Mission. To the right are the homes of East Scarborough west of Taylor, which had been fully built up since 1912. (Church of the Redeemer.)

BEST WISHES OF THE SEASON

FAIRMOUNT COMMERCIAL DISTRICT. PICTURED in this recent Christmas card from the City of Cleveland Heights, this little shopping area between Taylor and Queenston probably dates from the early 1920s. By the end of the decade, the district included Joseph Bloom, grocer; Thomas P. O'Brien, butcher; James Q. McKearney, confectioner; a Fisher Brothers; a Great Atlantic & Pacific Tea Company; a drug store and a delicatessen; a hardware store; and the shop of dressmaker Helen E. Garrett. (CHPDD.)

IDLEWOOD VILLAGE, FOURTH OF JULY, 1990. Residents of the "royal streets," plus Canterbury and East Scarborough, stage this annual event with flags and a marching band. (Nancy Schwab.)

CANTERBURY SCHOOL MURAL. Created by George Woideck, this ceramic celebrates the racial diversity of this school and neighborhood and adds color and drama to the school's exterior. (James W. Garrett IV.)

BRADFORD PATH, 2004. The path from Taylor to Canterbury Road takes children to school and on summer bike rides. Like the homes nearby, the path captures the rural charm of the long-ago village of Idlewood. (James W. Garrett IV.)

70

Three
COMMUNITY LIFE
COMPLEXITY AND DIVERSITY
1920–1945

PRESENTING YOUR SCHOOLS

Cleveland Heights Public Schools
Cleveland Heights, Ohio
1941

**PRESENTING YOUR SCHOOLS,
1941.** These formally dressed children, very possibly on a field trip, were part of the Cleveland Heights school population, which escalated from 2,300 students in 1918 to 9,200 students in 1940. On Noble, Lee, Coventry, and Taylor, the school district added to and built new schools, merchants built shops, and congregations built houses of worship. All served an increasingly diverse community. (Cleveland Heights-University Heights Board of Education.)

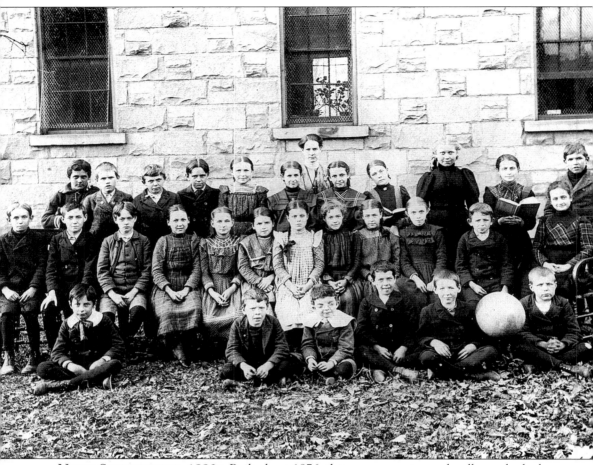

NOBLE SCHOOLHOUSE, 1890s. Built about 1876, this one-room stone schoolhouse looked very similar to the Superior Schoolhouse and served children through the first four grades. In 1929, Josephine Armstrong recalled her teaching stint here three decades earlier: "The little school consisting of twenty pupils was interesting. They came and stayed all day, bringing their lunches with them. . . . If it were too warm in the school house on a spring day, the pupils prepared their lessons under the shade of the great maples in the yard. . . . Sometimes the entire school walked out at noon time . . . and gathered the early spring flowers, picnicked in the woods, or in winter took their sleds to the hillside and slid down with no fear of traffic." This was still a rural community: "Many of these people were dairymen; some were gardeners. They had a long day, rising long before light; returning from their routes in the afternoon, they were busy with the cares of farm and herd until dark again." (WRHS.)

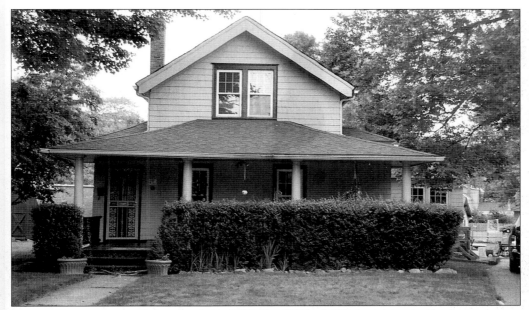

NOBLE FARMHOUSE. Constructed in 1851 for Willard Wight, this simple farmhouse, a designated Cleveland Heights landmark, is a reminder of this neighborhood's rural beginnings. Wight's 52-acre farm was sold in 1907 and subdivided for a residential development that would include Ardmore, Rosemond, and Navahoe Roads. (James W. Garrett IV.)

NOBLE NEIGHBORHOOD, 1914. This part of Cleveland Heights was still relatively undeveloped, although much of it had been divided up into small allotments, indicated on this plat map as "sub plans." These were developed piecemeal over the next two decades. At the top of the map appear the quarries in the Village of Bluestone, which was later annexed by Cleveland Heights and South Euclid. (WRHS.)

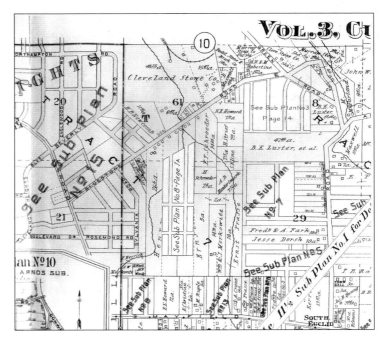

BLUESTONE ROAD FARMHOUSE. Another legacy of the farms and quarries of Bluestone, this farmhouse sits comfortably next to its twentieth-century suburban brick neighbor. Like the streets that were once part of Idlewood, the Bluestone neighborhood retains some of its original rural character. (James W. Garrett IV.)

NOBLE SCHOOLHOUSE, 1920s. This suburban classroom is a far cry from the one-room country schoolhouse of the 1890s. The new school building reflected the neighborhood's growth during the 1910s and 1920s, as farms were subdivided into residential streets. (WRHS.)

NOBLE ROAD LIBRARY. Another sign of the neighborhood's growth was this elegant building completed in 1936 and designed by Walker and Weeks. Possibly the best-known architectural firm in Cleveland, Walker and Weeks designed many distinguished local homes and buildings, including Severance Hall. This permanent home of the Cleveland Orchestra is named after John L. Severance, whose gift made the building possible. (James W. Garrett IV.)

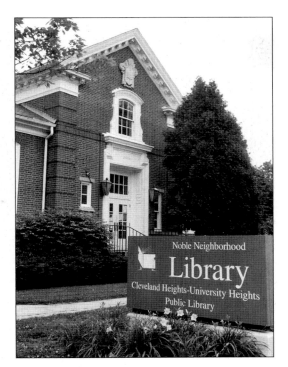

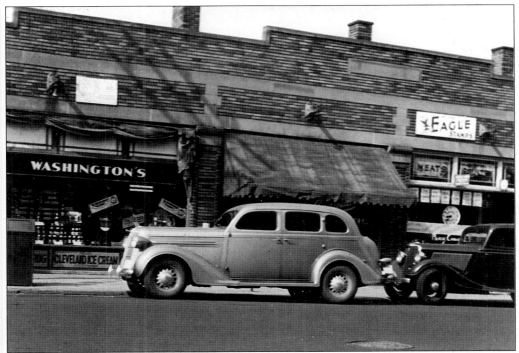

NOBLE AND GREYTON ROADS, 1930s. During the 1920s, Noble developed as the commercial center of the neighborhood. In 1931, Washington's Pharmacy sat at this corner; next door were a grocery and fruit store. This corner is now the site of Greyton Courts. (CHPDD.)

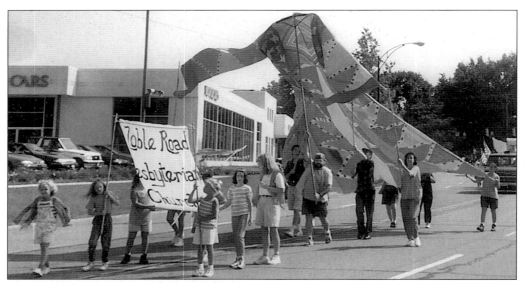

NOBLE ROAD PRESBYTERIAN CHURCH MEMBERS, 1996. Carrying colorful banners, members participated in the city's 75th anniversary parade. The congregation, a mission of the First United Presbyterian Church of East Cleveland, held its first services in 1907 in the one-room stone schoolhouse on Noble and constructed its own building in 1909, just to the north of the schoolhouse. In 1921, the congregation, now Noble Road Presbyterian Church, became independent of the East Cleveland church and in 1951, completed the colonial structure it now occupies. (Marian J. Morton.)

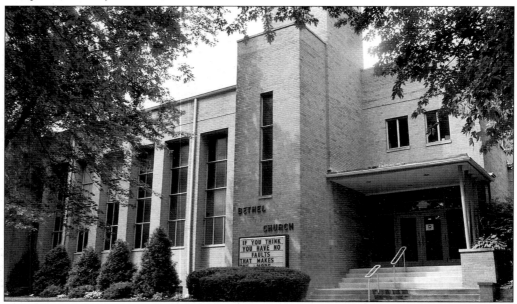

BETHEL CHURCH OF CLEVELAND HEIGHTS. The congregation was organized as the First Swedish Baptist Church in 1889. In 1952, participating in the post-World War II out-migration from Cleveland, the congregation moved from Addison Road and bought this site from the Heights Assembly of God (Pentecostal). The cornerstone for this building was laid in 1955. (James W. Garrett.)

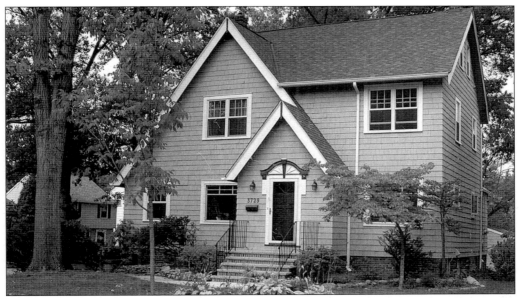

WOODRIDGE ROAD HOME. This Tudor revival was rehabilitated with the help of the Home Repair and Resource Center (HRRC). Born at Forest Hill Church in 1971 as the Forest Hill Church Housing Corporation, the agency responded to two simultaneous and pressing community concerns: harmonious racial integration and an aging housing stock. HRRC's goal was to guarantee bank loans for home repairs and home ownership for residents who might not qualify for conventional loans. Initially funded by the church and private contributions, HRRC now receives significant public monies, especially federal community block grant funds. (HRRC.)

GREYTON COURTS. City Architects designed these new cluster homes on Noble and Greyton. This high-density housing has an urban feel to it and like HRRC, responds to the suburb's changing housing needs. (James W. Garrett IV.)

NOBLE STREETSCAPE, 2004. Store owners have created this interesting landscape. In 1931, a baker, two grocery stores—a United Food Stores and a Fisher Brothers—and a butcher occupied the first floor of this small commercial block. Owners of the bakery and the butcher shop lived in the apartments upstairs. (James W. Garrett IV.)

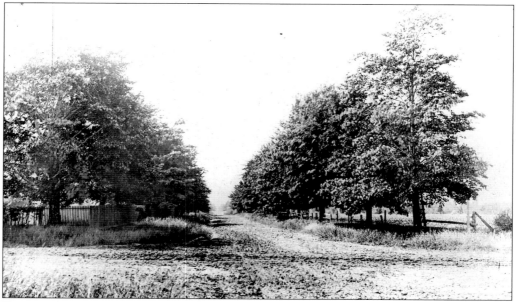

FAIRMOUNT AND LEE, C. 1900. Lee south of Fairmount was still a country road. However, on the corner to the left, John V. and Kenyon V. Painter built the Jacobean brick and stone mansion that was purchased in 1942 for Beaumont School. On the opposite corner now stands the monastery of the Carmelite Sisters on property purchased from Rollin White in 1935. (WRHS.)

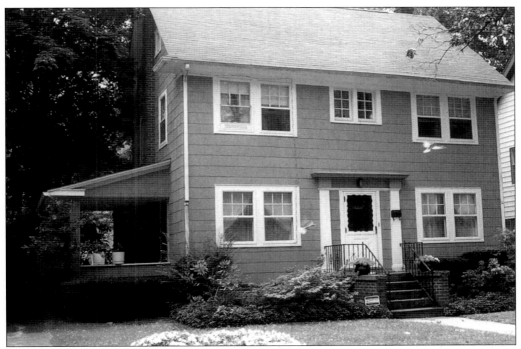

ORMOND ROAD, 1920. Home owners began buying properties on Ormond as early as 1915. In 1920, the census taker listed at this address, Bernard Lundun, 36, a toolmaker of Swedish descent, his wife Lillian, 29, and their two daughters. His neighbors on Ormond included two teachers, two carpenters, another toolmaker, a boat maker, and other skilled craftsmen of English, Swedish, and German origin. (James W. Garrett IV.)

KIT HOME ON ORMOND. In 1926, Sears and Roebuck marketed a two-bedroom bungalow like this one, poetically named "the Ardara," and advertised it thus: the bungalow "pleasingly combines oriental and occidental architecture." The attached garage is unusual for a house of this period. The "kit" included the plans, the pre-cut lumber, the roofing materials, and the paint for $2,483. (James W. Garrett IV.)

FAIRFAX SCHOOL, 1920. Built in 1916, Fairfax needed expanding only four years later. The home to the right is on Scarborough. The more distant homes to its left are on Coleridge Road. The many vacant lots would soon be filled. (WRHS.)

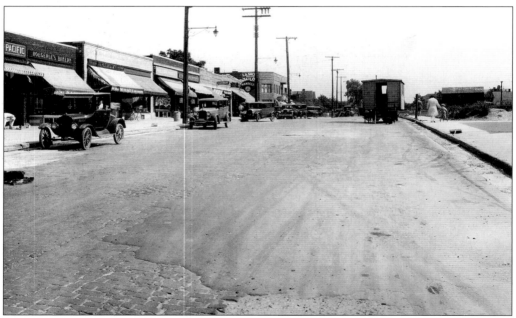

LEE AND SILSBY, 1928. North of Scarborough, the east side of Lee was lined with locally-owned shops like Hoegerle's Bakery, Wolf Hardware, and Mandel's Grocery and early chain stores like the Great Atlantic and Pacific Tea Company. The west side of Lee remained undeveloped. (WRHS.)

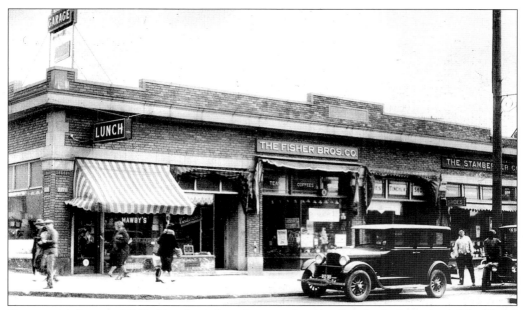

CEDAR AND LEE, C. 1928. THIS busy shopping area developed at the intersection of the Cedar streetcar and the Lee Road bus route during the 1920s. The longest-lived of these businesses was Mawby's restaurant, which remained at this location for almost 50 years. (CHPDD.)

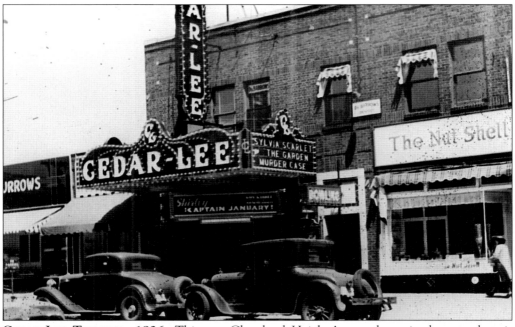

CEDAR-LEE THEATER, 1936. This was Cleveland Heights' second movie theater when it opened in 1925. (The Heights Theatre opened in 1921 at Euclid Heights and Coventry). The darkened balcony of the Cedar- Lee was the romantic setting for dating, according to the recollections of many Cleveland Heights residents. The theater complex is a designated Cleveland Heights landmark. (CHPDD.)

HEIGHTS HIGH FOOTBALL, 1927. Cleveland Heights High School moved from its site at Euclid Heights and Lee to its current location at Cedar and Lee in 1926. A year later, this "Lightweight Squad" not only failed to win the lightweight football championship for the first time since the league was formed, but won only one game, according to the 1927 *Caldron*. The varsity team fared better with a 3-5 record for the season. (WRHS.)

ROOSEVELT JUNIOR HIGH. When the new high school was completed in 1926, its former site at Lee and Euclid Heights became this junior high school. The building, which faced on Lee, was later demolished. (Cleveland Heights-University Heights Board of Education.)

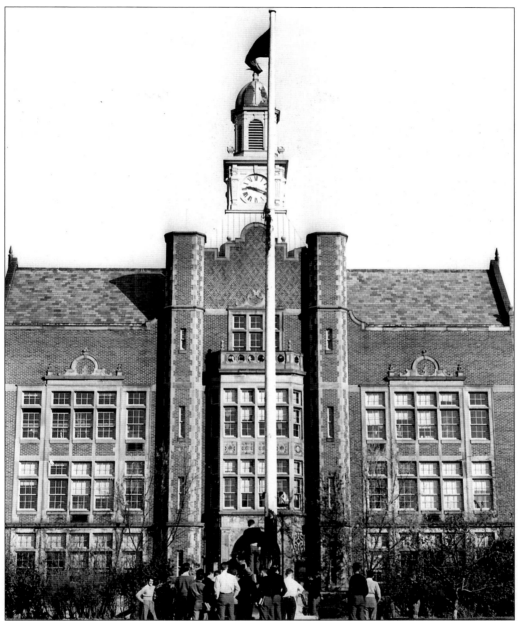

HEIGHTS HIGH, 1933. This photograph emphasizes the verticality of the original entrance to the high school, accentuated by the flag pole, the turrets, and the clock tower. Architect Franz Warner also designed Coventry, Boulevard, and Taylor Schools. The decorative brick and dramatic windows were typical of Cleveland Heights schools built during the prosperous 1920s. These high school students, however, faced an uncertain future in the early years of the Great Depression. In the 1933 *Caldron*, class poet Kate Serlin wrote this "Reverie on a Launched Vessel": "Will my ship come rushing home \ With great victorious sails outspread \ . . . Or, will it too, meet its doom, \ A faint-hearted vessel, Whipped and beaten in its battle \ On the Sea of Life . . . ?" (Special Collections, Cleveland State University.)

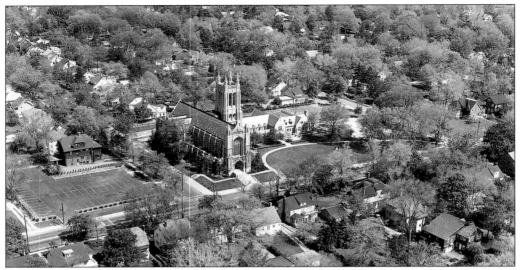

LEE ROAD, 1967. In the center of the photograph is the distinguished French Gothic revival Church of the Saviour, designed by John W.C. Corbusier, William Foster, and Travis Gower Walsh. Neighboring streets east and west of Lee are fully built up, the homes barely visible through the mature trees. (Church of the Saviour.)

SCARBOROUGH ROAD, C. 1974. Costumed children and decorated bicycles distinguished this annual block party. Scarborough was laid out in 1911 by the James J. Hinde Realty Company as part of its Coventry Subdivision, which also included Coleridge, Corydon, and Essex Roads. "Schools and churches are convenient. Coventry and its surroundings compose a vast and beautiful park," maintained the realtor. By the end of the 1920s, these streets west of Lee were completely developed. (Karen Laborde.)

CEDAR-LEE MURAL. Sponsored by the Heights Arts Collaborative, the Cedar Lee Merchants Association, and Cleveland Cinemas, this 36-by-120-foot mural on the back of the Cedar-Lee Theater complex was created in 2001 by Robert A. Muller, principal photographer and coordinator of Photographic Services at the Cleveland Institute of Art. Muller himself is pictured here as he took the photographs of the Lee Road buildings that he recreates, capturing the energy of Lee Road's past and present. (James W. Garrett IV.)

LEE ROAD LIBRARY, 2004. Visitors to the busy library are greeted by this ceramic sculpture, *Open Book*, by Marvin Smith. A long-awaited expansion and renovation of this building, linking it with the former site of the YMCA across Lee, is finally underway. (James W. Garrett IV.)

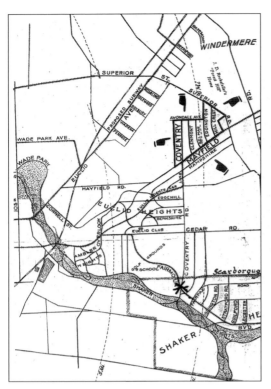

NORTH COVENTRY NEIGHBORHOOD. In the 1910s, the Coventry-Mayfield Land Company developed Glenmont, Belmar, Eddington, Hillcrest, and Coventry Roads. To attract customers, the developer's map highlighted the most prestigious sites in the area: the home of John D. Rockefeller, the Euclid Club, and the Van Sweringens' Shaker Heights allotment. (WRHS.)

GLENMONT DOUBLE. "Ideal sites for double houses," announced the developer. Spacious and typically more elaborate than the Minor Heights doubles, many became homes for the Jewish families who began to move into Cleveland Heights in significant numbers in the 1920s. The neighborhood was close to Jewish institutions like the Mayfield Cemetery, the Heights Orthodox Congregation, the Temple on the Heights (B'nai Jeshurun), and the shops on Coventry. (Marian J. Morton.)

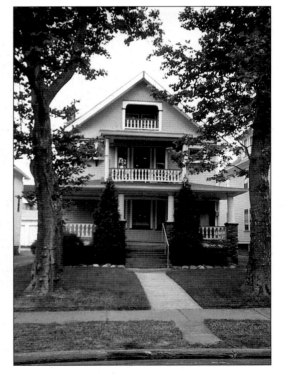

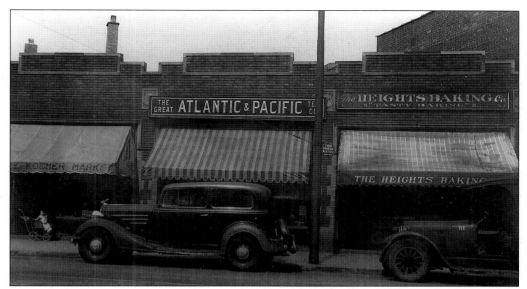

COVENTRY SHOPS, 1920S. Coventry developed as a commercial area along the tracks of the streetcar as it traveled north to Mayfield from Euclid Heights. The kosher market on the left was one of many shops on Coventry that catered to a Jewish clientele. At the end of this decade, Coventry was also home to Hyman Dembovitz, baker; Robert Katz, meats; Sharensky Brothers, meats; Apple and Tuchman, furs; Edward Solomon, delicatessen; and Weiskopf Brothers, hardware. (CHPDD.)

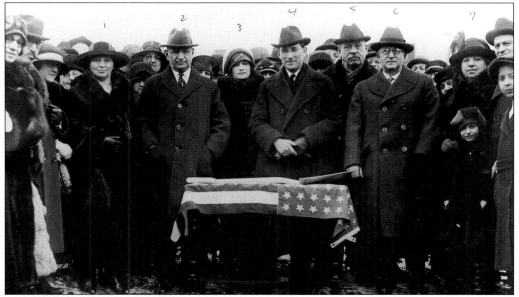

Ground Breaking at B'Nai Jeshurun, 1924. This Conservative Jewish congregation moved to Cleveland Heights from East 55th and Scovill Avenue in Cleveland. After this ground breaking, construction was halted for several months when John D. Rockefeller, owner and developer of the property across Mayfield, tried to persuade the congregation to build instead on a larger parcel on Superior. The business deal fell through, and the building was completed in 1926. Architect Charles Greco also designed the Montefiore Home across Mayfield. (WRHS.)

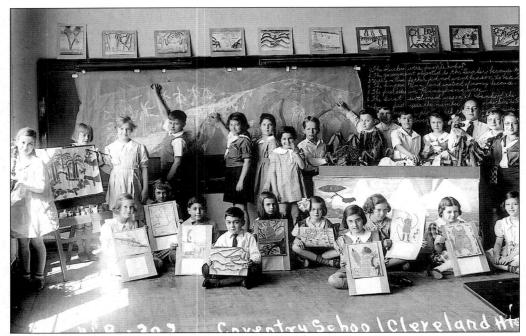

COVENTRY SCHOOL CLASSROOM, C. 1929. Voters turned down bond issues to build the school in 1916 and 1917. A third bond issue passed, but construction was slowed by the United States' entrance into World War I. When the school opened in 1919, it was filled to capacity, like this classroom of lively fourth-graders. (Coventry School Media Center.)

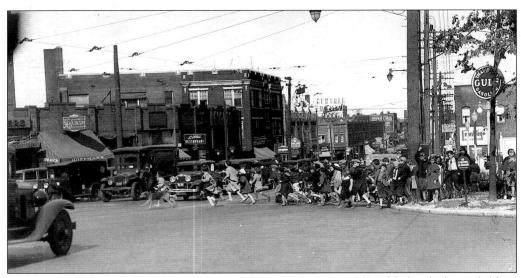

CHILDREN CROSSING COVENTRY, C. 1935. Leaving Coventry School behind, these children dashed across the busy street. According to the *Cleveland Heights Press*, in 1925–26, Coventry School was the largest of the elementary schools with 927 students; Fairfax had 840; and Boulevard, 609. Only the new high school was slightly larger with 927 students. (CHPDD.)

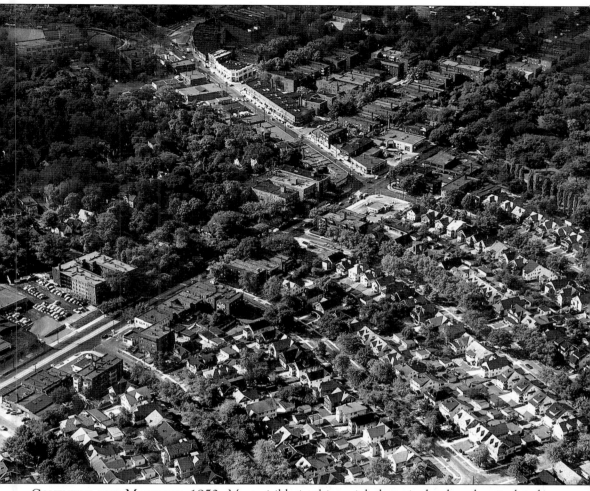

COVENTRY AND MAYFIELD, 1953. Most visible in this aerial photo is the densely populated North Coventry neighborhood at the lower right of the photograph and the distinctive white terra cotta exterior of the Betty Burke Building at Coventry and Lancashire in the upper center. At the upper right is Mayfield Cemetery, established in 1887 by congregation Tifereth Israel. In the upper left-hand corner, barely visible through the trees, is Coventry School. (Ben Lewis.)

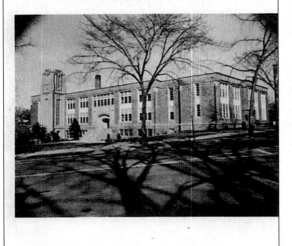

"Strengthening The Structure"

COVENTRY SCHOOL P. T. A.

2826 Euclid Heights Boulevard

FA. 1-7348

1963 — 1964

COVENTRY SCHOOL, 1963. Designed by Franz Warner, this imposing building sat on a bluff at the intersection of Euclid Heights Boulevard, Washington Boulevard, and Coventry. This PTA annual report had as its theme "Strengthening the Structure." Ironically, the building's structure would be demolished in 1976 and replaced by a smaller, more energy-efficient building. (Coventry School Media Center.)

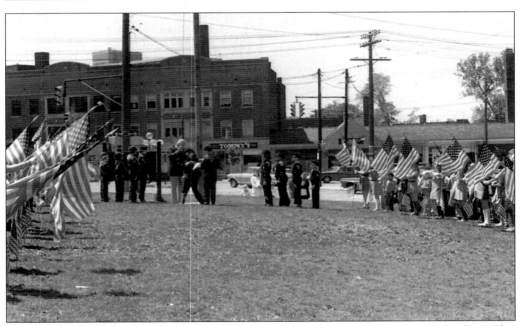

COVENTRY STUDENTS, 1967. These children participated in a patriotic event (perhaps Flag Day) on the school's front lawn. In the background are buildings that were later destroyed by fire, including the original site of Tommy's Restaurant. (Coventry School Media Center.)

ROCK COURT, 1978. During the 1960s and 1970s, Coventry became a center of the Cleveland Heights counter culture, the local version of San Francisco's Haight-Asbury. One of the last reminders of this era, these homes flaunted the flags and art work of this alternative lifestyle. They were torn down to enlarge the municipal parking lot, and the remainder of Rock Court became a private road. (Photograph by Bill Nehez, Special Collections, Cleveland State University.)

COVENTRY STREET FAIR. These colorful and tumultuous street fairs were annual affairs, sustaining Coventry's counter-cultural identity into the 1970s and 1980s. The fair was revived in summer 2004. (Joe Polevoi.)

HAMPSHIRE DOUBLE, 1999. Originally part of the Euclid Heights allotment, this street was developed as apartments and double homes after Calhoun lost control of the allotment. The duplexes often have front porches, up and down, and have similar scale and building materials. This duplex on the south side of Hampshire adjoins the large community garden. (Marian J. Morton.)

NEW NEIGHBORS. Some of Coventry's newest residents are from the former Soviet Union. They help to sustain Coventry's Jewish heritage and its eclectic quality. They are seen here in front of Musicians Towers on Lancashire Road, a federally subsidized high-rise apartment building, completed in 1974. (Marian J. Morton.)

COVENTRY STREET SCENE, 2004. Outdoor tables and new landscaping made Coventry a busy place on a sunny summer Saturday. Contrast this with the same view in the 1967 photograph on page 90. (James W. Garrett IV.)

COVENTRY ARCH, 2004. Composed of two embracing figures, the arch symbolizes the wish for harmony in an increasingly diverse community and marks the entrance to the Coventry School campus. The project was sponsored by Coventry PEACE, Inc. (People Enhancing a Child's Environment) and funded by several local foundations and individuals. The arch was created in 2001 by Barry Gunderson, professor of art at Kenyon College. (James W. Garrett IV.)

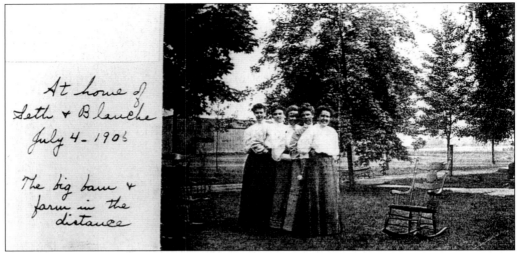

TAYLOR FAMILY, 1906. Taylor Road is named for the family of Henry Taylor, who purchased a 122-acre farm between Euclid Avenue and Mayfield in 1849. His son, Charles W. Taylor, and his grandson, Seth Taylor, the husband of Blanche Minor, also lived on the property pictured here. This photograph is in the family scrapbook. (WRHS.)

HOPE LUTHERAN CHURCH. Built in 1951, this church stands on the site of one of the Taylor farmhouses. Most of the Taylor property was sold to the Rockefeller family in 1916 and became part of the (second) Forest Hill development. (Hope Lutheran Church.)

SPANGLER ROAD VOLUNTEERS. In 1992, HRRC, renovated this home in the Caledonia neighborhood that had been reclaimed by a local bank. In financial partnership with the bank, 100 volunteers painted, plastered, and put this seriously deteriorated house in good condition. (HRRC.)

CALEDONIA PARK. Purchased from the City of East Cleveland, this small park in the northern-most corner of Cleveland Heights is surrounded by towering trees. In 1916, residents of this neighborhood tried unsuccessfully to secede from Cleveland Heights to join the City of East Cleveland because their children attended East Cleveland public schools. Recently, residents of this neighborhood tried unsuccessfully to have their children transferred to Cleveland Heights schools. (James W. Garrett IV.)

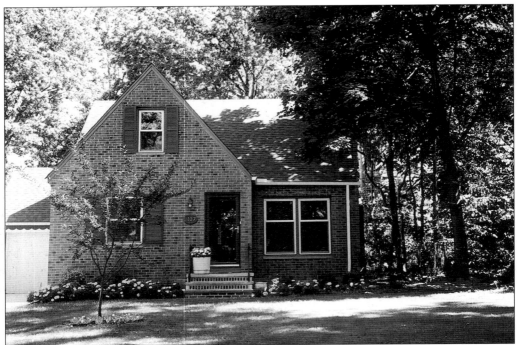

CASTLETON ROAD HOME. This home, also renovated with the help of HRRC, is in a neighborhood first developed in the 1920s as "Potter Estates," named after the family that owned substantial property on this east side of Taylor. Although the developer boasted in 1923 that his allotment was "in the center of one of the most beautiful sections of the Heights" and "directly across . . . from the Forest Hill, the famous residence of John D. Rockefeller," this street did not get built up until the late 1930s. (HRRC.)

ST. LOUIS CHURCH, 1951. Established in 1947, this congregation worshiped first at the Center-Mayfield Theater and then in a home on Mayfield Road. This building and St. Louis School on North Taylor opened in 1951. (*Catholic Universe Bulletin.*)

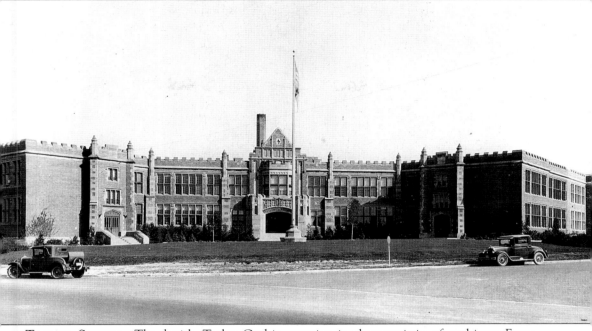

TAYLOR SCHOOL. The lavish Tudor Gothic exterior is characteristic of architect Franz Warner's work for the Cleveland Heights school district in the 1920s. When the building was completed in 1923, its interior was equally elaborate with leaded glass windows and an auditorium that seated 500 students. In the early 1970s, however, in the context of rising energy and maintenance costs and a shrinking school population, Taylor School was demolished and replaced by a smaller, less pretentious contemporary building. So were Boulevard, Coventry, and Fairfax Schools. (Cleveland Heights-University Heights Board of Education.)

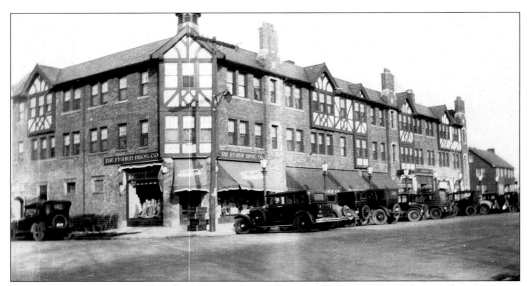

STADIUM SQUARE. This Tudor-style complex of shops and apartments at the northwest corner of Superior Park and Taylor Roads was completed in 1929. It was called Stadium Square because of a football stadium proposed for the eastern end of the nearby park. First tenants included Frank Aniaz, a barber; the beauty shop of Emily O. Martins; Newman Dry Cleaning; Peter Fena and Albert Copperman, who sold fruit; Edward F. Stumpfl, a baker; and a Fisher Brothers grocery. (CHPDD.)

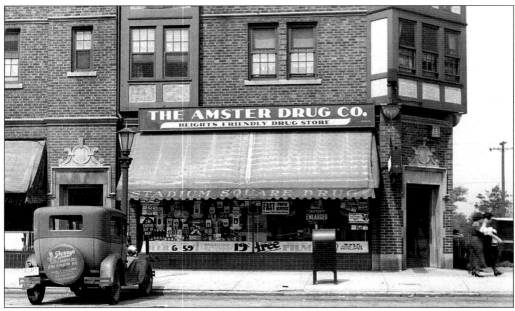

AMSTER DRUG, C. 1935. The "Heights Friendly Drugstore" sat across Superior Park in the second retail-apartment building of Stadium Square. In the years after World War II, Taylor Road replaced Coventry as the center for Jewish life in Cleveland Heights. Taylor became the site of Taylor Road Synagogue, the Bureau of Jewish Education, Jewish Family Services, and several small Orthodox congregations. (CHPDD.)

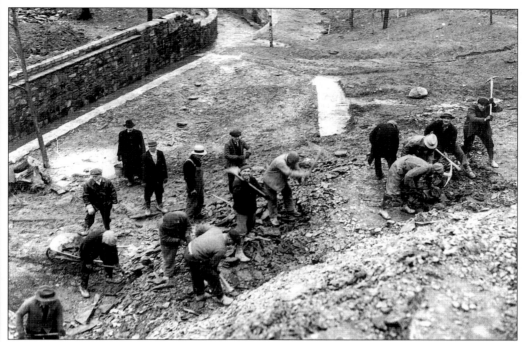

Cain Park Under Construction. Dugway Brook ran through the ravine in this heavily wooded spot, where the Haycox family briefly operated a quarry. Although Cleveland Heights had begun to buy properties for a park system in 1916, this site was originally used for a dump, much to the neighbors' displeasure. During the 1930s, however, the federal Works Progress Administration put unemployed men to work building the culvert, tennis court, and pavilion. (WRHS.)

Cain Park Stage, 1939. In 1934, Dr. Dina Rees Evans, a faculty member at Heights High, directed the first theatrical performance (*Midsummer Night's Dream*) in the ravine at the eastern end of the park, which was simultaneously named for Mayor Frank C. Cain. In 1939, the amphitheater was completed, and productions included *My Maryland*, *The Warrior's Husband*, and *Sherwood*. The amphitheater was named after Evans; the smaller theater was named for Cain's wife, Alma Lambert Cain. (CHPDD.)

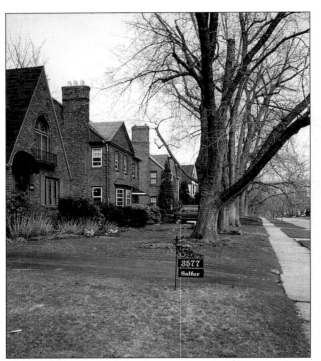

SEVERN ALLOTMENT. In 1915, John L. Severance purchased the property that now includes Severn, Shannon, and Bendemeer Roads, which he began to develop in the 1920s. In 1929, a new Georgian colonial on Severn with four bedrooms and maids' quarters on the third floor sold for under $20,000. "A snappy bargain," maintained the realtor. Not until after World War II, however, were significant numbers of homes built, most in the brick colonial style shown here. Their building occurred simultaneously with the large influx of Orthodox Jews into Cleveland Heights, who remain a visible presence in the Taylor Road neighborhood. (Marian J. Morton.)

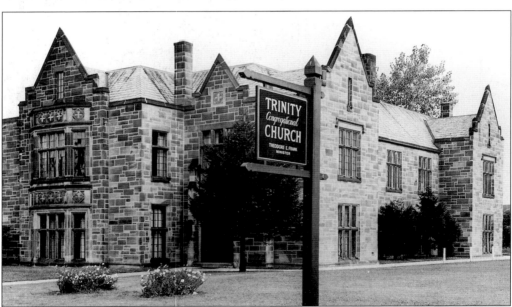

TRINITY CONGREGATIONAL CHURCH. In 1944, an estimated 27,000 Jews lived in the suburb, an increase of 15,000 since 1937. A sign of this rapid in-migration, this traditional Gothic church on Washington Boulevard was purchased in 1947 by Community Temple, which had broken away from B'nai Jeshurun in 1933. The Jewish congregation built an addition to this original structure in 1952. The Taylor Road neighborhood was within walking distance of synagogues and temples and dozens of stores that catered to a Jewish clientele. (WRHS.)

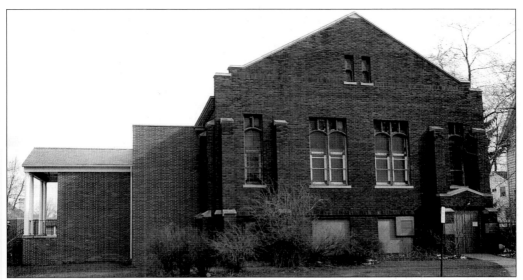

SINAI SYNAGOGUE. In 1953, Beth Hamedrash Galicia (Sinai Synagogue) purchased this building at DeSota and Bainbridge from Messiah Lutheran Church and added the pillared entrance to the left in the colonial style popular for churches in the post-World War II period. (CHPDD.)

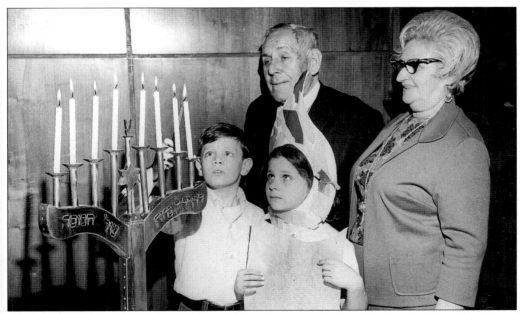

JEWISH COMMUNITY CENTER, 1967. The Jewish Community Federation chose the site of Elisabeth Severance Allen Prentiss's Glen Allen for this facility because an estimated 30,000 Jews lived within a two-mile radius. The building of the largest Jewish social service and recreation facility in the Cleveland area sparked considerable controversy but reaffirmed the Jewish presence in the Taylor neighborhood. After its completion in 1960, the center became the location for a wide variety of recreational and cultural programs, especially those celebrating the Jewish heritage. In 2004, the center's property was sold to a developer, indicative of the Jewish out-migration from Cleveland Heights. (WRHS.)

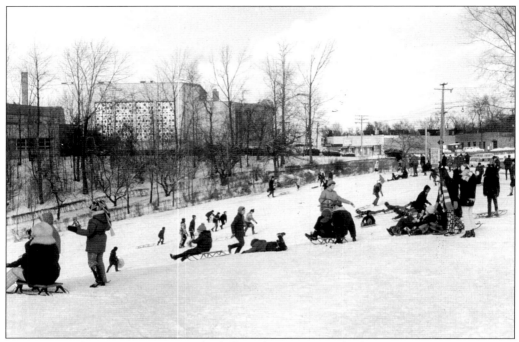

Winter at Cain Park, 1971. The hill at the eastern end of Cain Park never became a football stadium, but it did become—and has remained—a popular place for sledding. The imposing Taylor Road Synagogue complex appears in the background. (CHPDD.)

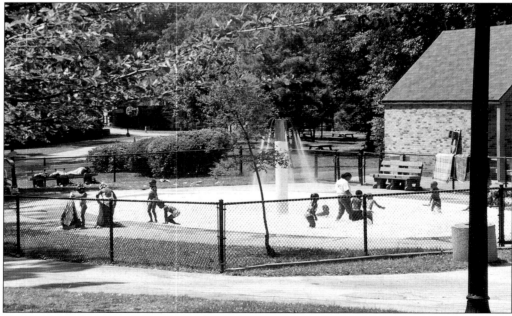

Summer at Cain Park, 2004. The park hosts an arts festival and musical theater and concerts in the Evans Amphitheater and the Alma Theater, but it is also home to summer camps and kids that just like to splash around in the wading pool. (James W. Garrett IV.)

Four

AUTOMOBILE SUBURB
PARKS, PARKING, AND RANCH HOMES
1940–1980

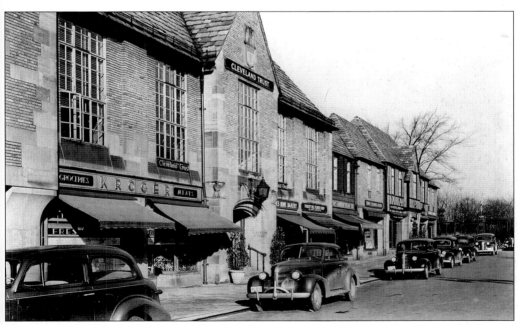

HEIGHTS ROCKEFELLER BUILDING, 1938. This was to be the commercial center of a residential community of 600 homes planned during the 1920s by John D. Rockefeller Jr. Completed in 1930, this building set the tone for the Forest Hill development: all homes were to be in this French Norman style, and all were designed for automobile owners. Other post-war housing and commerce also accommodated the automobile. (WRHS.)

ROCKEFELLER ESTATE. The lily pond was on the landscaped grounds of Rockefeller's summer home, Forest Hill. The home was in East Cleveland, but Rockefeller's property spanned both East Cleveland and Cleveland Heights. (CHPDD.)

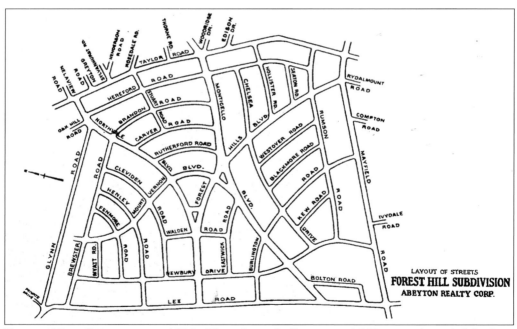

FOREST HILL SUBDIVISION, 1929. The planned allotment of 360 acres, bounded by Lee, Mayfield, Taylor, and Glynn Roads, also spanned both suburbs. With its $60 million price tag, it was eagerly anticipated by officials and residents of both cities. The curving streets with English names were laid out by Barton R. Deming, creator of the Euclid Golf allotment. However, possibly due to the difficulties of acquiring all the properties, the construction of housing did not get started until 1929. (Sharon Gregor.)

BREWSTER ROAD, 1930. In February, this bleak view of Brewster east from Lee shows only a muddy road, construction equipment, and outbuildings. Completed homes on Glynn in East Cleveland are visible on the left. Only 81 of the French Norman homes were completed, most of them in East Cleveland. (East Cleveland Public Library.)

BREWSTER HOMES, 1931. The Depression, and the homes' high prices—$40,000 for a home on a corner lot—halted home sales. In 1931, Brewster had only one resident (in the East Cleveland section), although all the homes on the street had been built and carefully landscaped. (Special Collections, Cleveland State University.)

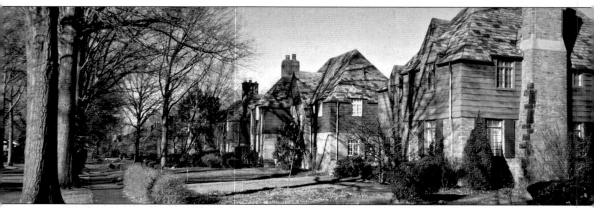

ROCKEFELLER HOMES. Architect Andrew J. Thomas used nine home designs and placed the homes in pairs that would be mirror images of each other. The resulting uniformity and the attached garages of the homes would be the model for the rest of the development, although the style of the homes would change. Stringent deed restrictions on home design were matched by restrictions that initially made it almost impossible for Jews or African Americans to buy homes in the development. (Marian J. Morton.)

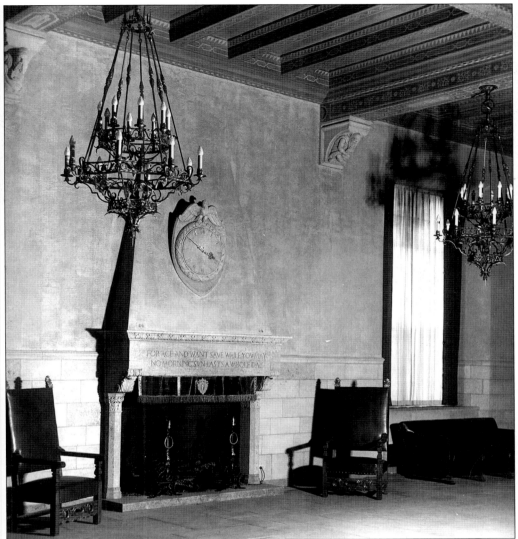

INTERIOR, CLEVELAND TRUST, C. 1930. Thomas also designed the Heights Rockefeller Building; this bank occupied its center. The bank's well-appointed interior complemented the building's handsome facade. Despite the elegance of the chandeliers, the carved figures, and the stenciled ceiling, the words carved over the fireplace advised thrift: "For Age and Want Save While You May / No Morning Sun Lasts a Whole Day." The Forest Hill District and the Heights Rockefeller Building are listed on the National Register of Historic Places, and the Heights Rockefeller Building is also a designated Cleveland Heights landmark. (CHPDD.)

107

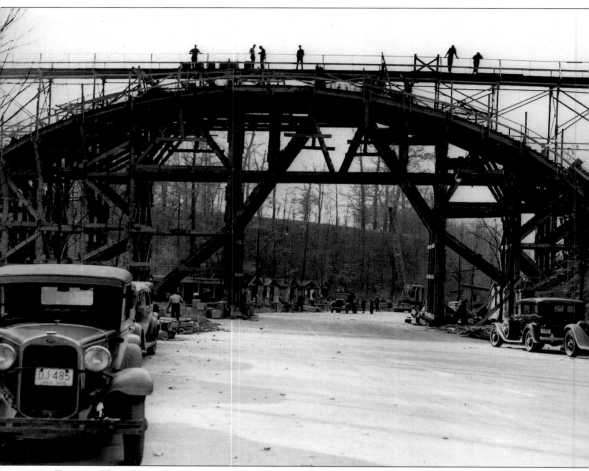

FOREST HILL PARK FOOTBRIDGE, 1939. The Rockefeller family gave the 235-acre Forest Hill Park to the cities of East Cleveland and Cleveland Heights in 1938. This footbridge over Forest Hill Boulevard, completed in 1941, connected the two parts of the park. The work on the bridge and elsewhere in this park, as in Cain Park, was completed by the Works Progress Administration, an effort to employ residents on works of public significance. A.D. Taylor, the creator of Cumberland Park, also laid out this park, which is on the National Register of Historic Places. (Special Collections, Cleveland State University.)

MONTICELLO BOULEVARD. In the 1920s, city officials had envisioned Monticello as the Fairmount Boulevard of the north side: broad, lined with tall trees and gracious homes, and with a streetcar running down its middle. By the time this western end of Monticello was laid out, however, the days of the streetcar were about over, and Monticello became a four-lane automobile highway. (James W. Garrett IV.)

FOREST HILL PRESBYTERIAN CHURCH. This congregation, formerly Cleveland Heights Presbyterian, moved from Mayfield and Preyer (see page 32) to Monticello and Lee Boulevard in 1951. Its first two locations had been a home on Radnor (1903–1906) and the Superior Schoolhouse (1906–1908). The church's colonial style complemented nearby homes. (Forest Hill Presbyterian Church.)

HOLLISTER ROAD HOME. This street contains some of the first homes in the Forest Hill allotment built after the Great Depression, some as early as 1940. This low-slung Cape Cod, informal and even more reminiscent of early America than the colonial homes popular after World War II, is typical of this street. (Marian J. Morton.)

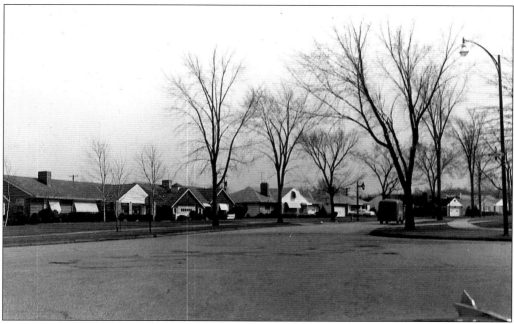

MOUNT VERNON AND NORTHVALE BOULEVARDS, 1961. These sprawling ranch homes, built in the 1950s and the last in the Rockefeller allotment, mandate large lots. Their horizontal lines and informality are quite different from the French Norman homes of Brewster Road, but in both neighborhoods, the streetscapes are uniform. (CHPDD.)

WILLIAM T. QUILLIAMS HOUSE. An early resident of East Cleveland Township, Quilliams was a carpenter who served in the Union Army during the Civil War. He built this farmhouse in 1867 on the road named after his family in the Oxford Neighborhood. This Greek revival home, a designated Cleveland Heights landmark, sat on a large farm that still contained 30 acres in 1903. Like other long-time residents including the Preyer, Haycox, Taylor, Minor, Penty, Hecker, Rockefeller, and Severance families, the Quilliams family turned their property into suburban allotments. However, this northern-most section of the suburb was not readily accessible by automobile until the 1940s after the improvement of Monticello Boulevard by the Works Progress Administration. (James W. Garrett IV.)

ENGLEWOOD ROAD. In 1920, there were only two homes on Englewood, both near Noble. By the end of the decade, however, this street in the Oxford neighborhood was almost fully built up. Homes like these, intended for middle-income suburbanites, were built on modest lots in styles that ranged from bungalows to modified farm houses. In 1929, Englewood's residents included two contractors and the owner of an "auto livery" firm. (James W. Garrett IV.)

LOWELL ROAD HOME. This Tudor revival is typical of homes built in the Oxford neighborhoods during the 1920s. HRRC helped in this rehabilitation, providing funds, expertise, and landscaping. (HRRC.)

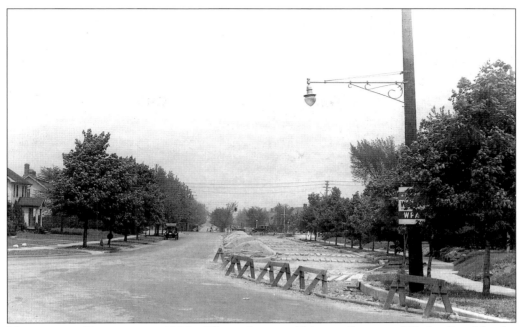

MONTICELLO BOULEVARD, 1930S. The widening of Monticello east of Taylor Road by the federal Works Progress Administration (WPA) put Cleveland Heights residents to work and also spurred the development of streets like Quarry, Keystone, and Renfield Roads. (CHPDD.)

OXFORD SCHOOL MURAL. The school also benefited from the Works Progress Administration, which in 1937 commissioned Gladys Carambella to paint murals of Cinderella and the Pied Piper. The murals were recently restored with a grant from the Cleveland Foundation. Oxford School also owns WPA-sponsored ceramic figures by Cleveland Heights resident Edris Eckhardt. (Community Relations Department, City of Cleveland Heights.)

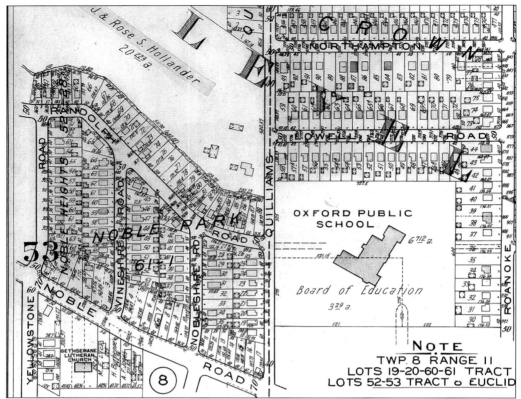

OXFORD SCHOOL NEIGHBORHOOD, 1941. The streets around the school were already densely settled, indicated by the small rectangles. However, the large properties of the Hollander and Quilliams family, to the north, remained undeveloped. This area became the first and the last large single-family housing development built in Cleveland Heights. (WRHS.)

QUILLIAMS SUBDIVISION. The subdivision ultimately included Fenley, Brinkmore, Mount Laurel, Atherstone, Langton, Runnymede, and Burbridge Roads. The ranch homes, like this one on Burbridge, were on generous lots that accommodated their horizontal lines and attached garages. Most homes in the subdivision were built in the 1950s, and when it was completed in the early 1960s, Cleveland Heights was substantially built out. (James W. Garrett IV.)

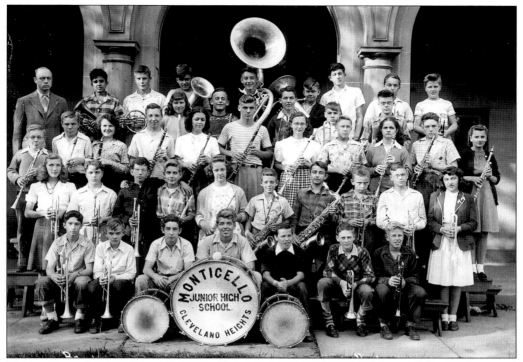

MONTICELLO JUNIOR HIGH SCHOOL BAND, C. 1947. The completion of the city's second junior high in 1930 responded to the growing population of the northeastern section of Cleveland Heights. The school system developed a nationally recognized music program in the 1930s. (CHPDD.)

MONTICELLO JUNIOR HIGH SCHOOL BAND, 1996. Continuing the suburb's tradition of musical excellence, this band played in the city's 75th anniversary parade. This band also celebrated the suburb's racial diversity. (Marian J. Morton.)

SITE OF DENISON PARK. Cleveland Heights acquired this former quarry from South Euclid and used it first as a public dump. (The quarry appears on the 1914 map of the Noble neighborhood on page 73.) In 1955, however, the city opened Denison Park at this location, named after long-time councilman Robert F. Denison, to serve the residents of the rapidly growing Oxford neighborhood. (CHPDD.)

MEMORIAL DAY PARADE, 1990. The city's annual Memorial Day parade was held in the Oxford neighborhood until 2000. Parade participants included these children and adults on bikes; the Noble Road fire station appears in the background.In the lower photograph, the Northhampton Precision Lawnmower Brigade is gathered in the Oxford School parking lot. (Community Relations Department, City of Cleveland Heights.)

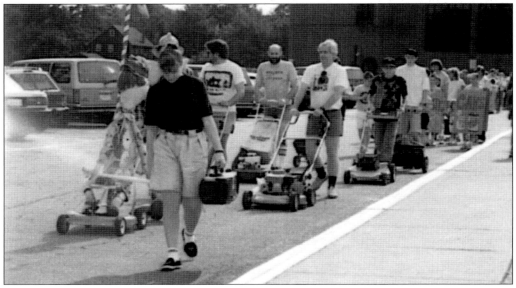

DENISON PARK, 2004. The park now contains a swimming pool, tennis courts, and this baseball diamond, which was full of lively kids and parents on a sunny July Saturday. (James W. Garrett IV.)

OXFORD SCHOOL GARDEN, 2004. In contrast, these gardeners enjoyed a quiet moment in the shade as they oversaw their plots in this large community garden adjacent to Oxford School. (James W. Garrett IV.)

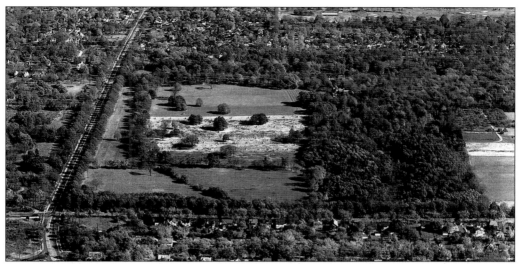

SEVERANCE ESTATE, 1949. John L. Severance's estate, Longwood, occupied 125 acres at the southeast corner of Taylor and Mayfield. At his death in 1936, his cousin's son, Severance Millikin, inherited the property. His mansion is barely visible among the trees in the center of the photograph. In the post-World War II period, Millikin made three separate efforts to build a regional shopping center on the site, launching a bitter, protracted community controversy, in the midst of which Millikin donated 13 acres at the southeast corner of the estate for the school named after him. The golf course of the Oakwood Club appears at the top of the photograph. (Bruce Young.)

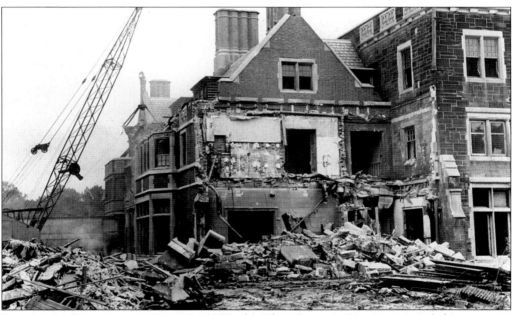

LONGWOOD DEMOLISHED, 1961. In 1957, the Ohio Supreme Court supported the necessary re-zoning for the site. This cleared the way for the demolition of the Severance mansion, designed by Milton Dyer and Charles Schweinfurth, and its formal gardens. The stable and a marble fountain, now in front of the city hall, are all that remain of the estate. (Special Collections, Cleveland State University.)

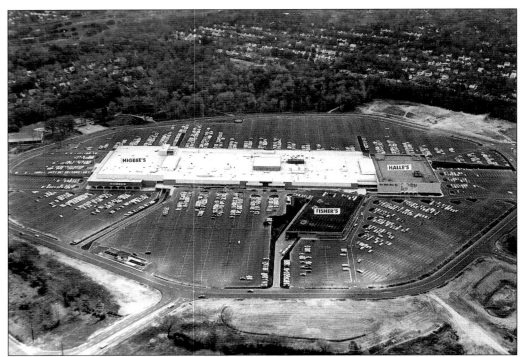

ACRES OF PARKING. The woods and pastures of the Severance estate were replaced by an enclosed mall and 50 acres of parking. Taylor Road was widened to accommodate the automobiles and busses that had replaced the streetcars. The trees on the shopping center's south side were intended to shield neighbors from this intrusion of commerce. The mall opened in 1963 with great fanfare. It housed two of Cleveland's finest department stores, Higbee's and Halle's, and dozens of specialty shops. Its interior was the location for many civic events. (Special Collections, Cleveland State University.)

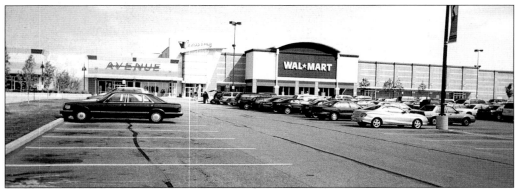

SEVERANCE TOWN CENTER, 2004. The shopping center fell upon hard times in the 1980s and 1990s due to the suburb's demographic changes and competition from other malls, especially upscale Beachwood Place. In 1996, the demolition of the enclosed shopping center began, and in 1999, a new strip mall opened with national chains like Borders Books and this Walmart. The automobile had triumphed. (Marian J. Morton.)

120

Five

ADAPTIVE REUSE
RESPONDING TO CHANGE
1980–2004

CHRIST OUR REDEEMER AFRICAN METHODIST EPISCOPAL CHURCH. Some of Cleveland Heights' oldest public and private institutions have adapted to the city's new populations. In 1982, this congregation purchased from the Church of the Brethren the former home of the Church of the Saviour at Superior and Hampshire (see page 26). The purchase signaled the growing in-migration of African Americans into Cleveland Heights; they accounted for 25 percent of the suburb's population in 1980. (Marian J. Morton.)

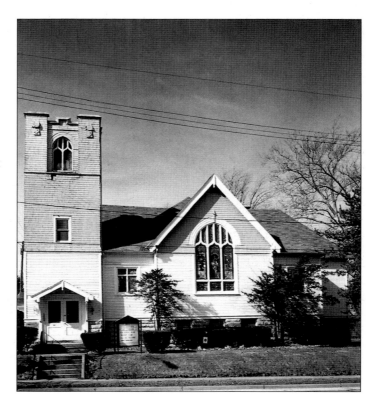

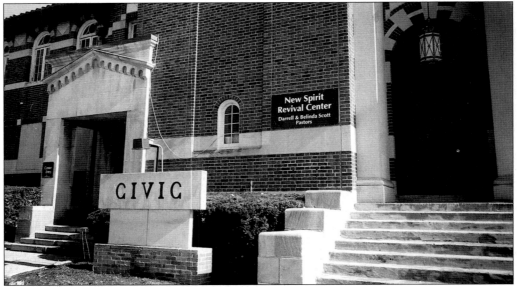

THE CIVIC / NEW SPIRIT REVIVAL CENTER. Particularly noticeable has been the exodus of Jewish institutions for suburbs farther east. In 1980, when the Temple on the Heights (B'nai Jeshurun) (see page 87) left Cleveland Heights, a non-profit corporation purchased and managed the building and in 2001, sold the building to the New Spirit Revival Center, a non-denominational African-American congregation. (Marian J. Morton.)

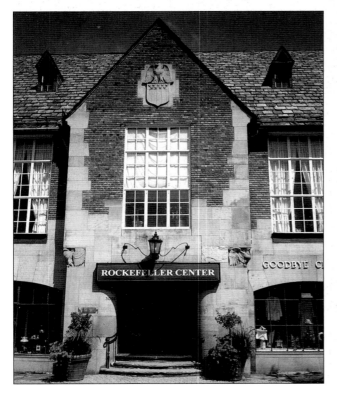

ROCKEFELLER CENTER. Formerly the Cleveland Trust Bank in the Heights Rockefeller Building (see pages 103 and 107), this space is currently rented for private parties and meetings. The elegant interior remains much the same. (Marian J. Morton.)

MOTORCARS HONDA. In 1986, in order to gain needed office space, as well as shore up the struggling shopping center, Cleveland Heights City Hall, including the police station, court, and jail, moved to Severance Center, which then became Severance Town Center. This auto dealer built a new structure on the site of the old city hall, but kept the 1924 handsome entrance (see page 47). (James W. Garrett IV.)

St. Alban / Edgehill Community Church. The original church building (see page 22) burned down in 1989. When the structure was rebuilt, other congregations shared its contemporary space. (Marian J. Morton.)

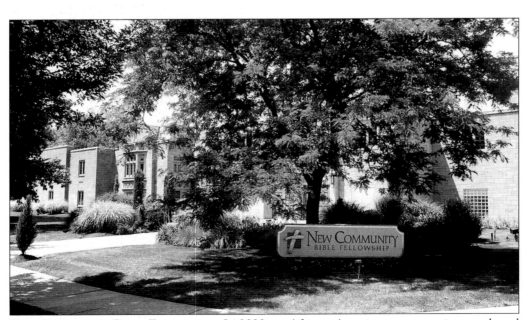

New Community Bible Fellowship. In 2000, an African-American congregation purchased this Gothic building from Community Temple (see page 100). According to the 2000 census, African Americans constituted 42 percent of the suburb's population. (James W. Garrett IV.)

Congregational Beth El. Although many Jewish institutions—Temple on the Heights, the Community Temple, the Bureau of Jewish Education, the Montefiore Home, and most recently, the Jewish Community Center—have left Cleveland Heights, this congregation stayed and purchased this building, first the site of Messiah Lutheran Church and then Sinai Synagogue (see page 101). The congregation removed the colonial entrance added in the 1950s and restored the building to its original Gothic design. (Marian J. Morton.)

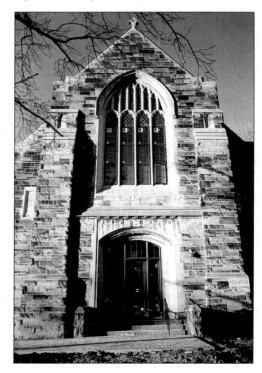

Brownstones at Derbyshire. The First English Lutheran Church on Euclid Heights Boulevard (see page 22) has been transformed into condominiums and cluster homes. The developer kept the church's dramatic Gothic entrance, and this new housing will retain the residential character of Calhoun's allotment. (Marian J. Morton.)

CLEVELAND HEIGHTS COMMUNITY CENTER. This was constructed around the old Recreation Pavilion (see page 47). In 1997, voters approved a bond issue to fund the improvement of the city's parks and recreation facilities. The plans for this building, however, angered historic preservationists, environmentalists, and others who opposed the building's large footprint, its cost, and its intrusion into the parkland. The ensuing controversy stalled the start of construction for two years. Finally completed in 2002, the new building contains two skating rinks, basketball courts, a senior center, a day-care center, and meeting rooms. It is in constant use. Here are campers returning from a swim at nearby Cumberland Pool. (James W. Garrett IV.)

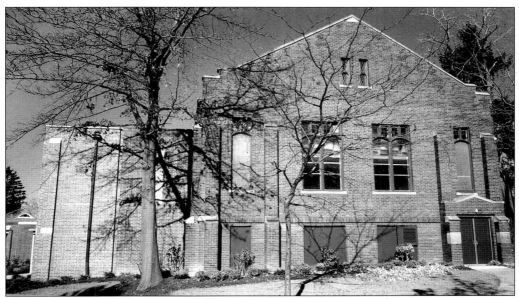

Congregational Beth El. Although many Jewish institutions—Temple on the Heights, the Community Temple, the Bureau of Jewish Education, the Montefiore Home, and most recently, the Jewish Community Center—have left Cleveland Heights, this congregation stayed and purchased this building, first the site of Messiah Lutheran Church and then Sinai Synagogue (see page 101). The congregation removed the colonial entrance added in the 1950s and restored the building to its original Gothic design. (Marian J. Morton.)

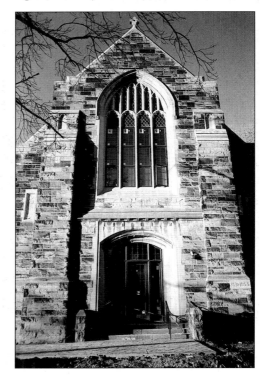

BROWNSTONES AT DERBYSHIRE. The First English Lutheran Church on Euclid Heights Boulevard (see page 22) has been transformed into condominiums and cluster homes. The developer kept the church's dramatic Gothic entrance, and this new housing will retain the residential character of Calhoun's allotment. (Marian J. Morton.)

CLEVELAND HEIGHTS COMMUNITY CENTER. This was constructed around the old Recreation Pavilion (see page 47). In 1997, voters approved a bond issue to fund the improvement of the city's parks and recreation facilities. The plans for this building, however, angered historic preservationists, environmentalists, and others who opposed the building's large footprint, its cost, and its intrusion into the parkland. The ensuing controversy stalled the start of construction for two years. Finally completed in 2002, the new building contains two skating rinks, basketball courts, a senior center, a day-care center, and meeting rooms. It is in constant use. Here are campers returning from a swim at nearby Cumberland Pool. (James W. Garrett IV.)

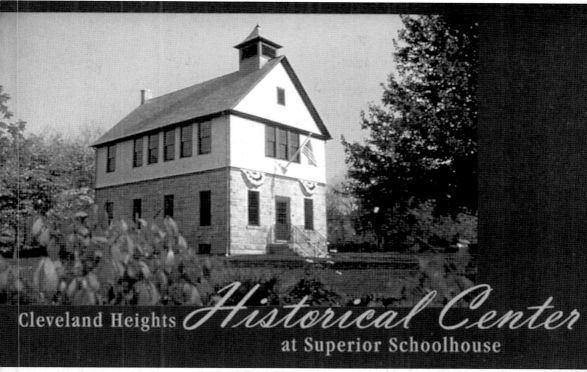

Cleveland Heights *Historical Center*
at Superior Schoolhouse

CLEVELAND HEIGHTS HISTORICAL CENTER. This is the city's oldest surviving public structure. It served generations of residents as Superior Schoolhouse (see page 25) and two congregations (the current Church of the Saviour and Forest Hill Presbyterian Churches) as a house of worship. For three decades, it became a storehouse for the city's carpenters. Completely restored with monies from the 1997 bond issue, the building has gained a new and appropriate use as the repository for Cleveland Heights' historic documents and photographs. The center stands as evidence of the city's reverence for its past and its hopes for its future. (CHPDD.)

BIBLIOGRAPHY

Books and Articles

Bellamy, John Stark. *Angels on the Heights: A History of St. Ann's Parish, Cleveland Heights, Ohio, 1915–1990*. Cleveland: privately printed, 1990.

Bremmer, Deanna L. and Hugh P. Fisher. *Images of America: Euclid Golf Neighborhood*. Chicago: Arcadia Publishing, 2004.

Caldron. Cleveland: Cleveland Heights High School, 1927.

Caldron. Cleveland: Cleveland Heights High School, 1933.

Evans, Dina Rees. *Cain Park Theater: The Halcyon Years*. Cleveland: Halcyon Printing Co., 1980.

Harris, Mary Emma and Ruth Mills Robinson. *The Proud Heritage of Cleveland Heights, Ohio*. Oberlin: Oberlin Printing Company, 1966.

Hellwig, Clayton. *More About "The Proud Heritage of Cleveland Heights."* Cleveland Heights: Creative Copy Associates, 1980.

Jackson, Kenneth T. *Crabgrass Frontier: The Suburbanization of the United States*. New York: Oxford University Press, 1985.

Johnson, Crisfield. *History of Cuyahoga County, Ohio*. Cleveland: Leader Printing Company, 1879; Reprint by Whippoorwill Publications, 1984.

Jones, Suzanne Ringler, editor. *In Our Day. Cleveland Heights: Its People, Its Places, Its Past*. Cleveland Heights: Heights Community Congress, 1986.

Morton, Marian J. *Cleveland Heights: The Making of an Urban Suburb*. Charleston, S.C.: Arcadia Publishing, 2002.

Van Tassel, David V. and John Grabowski, editors. *Encyclopedia of Cleveland History*. Bloomington: Indiana University Press, 1987.

Manuscripts and unpublished sources

B.R. Deming Company. Euclid Golf Allotment, Pamphlet. Western Reserve Historical Society (WRHS.), n.d.

Coventry-Mayfield Land Company. Pamphlet 1125. WRHS, c. 1912.

Hamley, Kara. "Cleveland's Park Allotment: Euclid Heights, Cleveland Heights, Ohio and Its Developer, Ernest W. Bowditch." Master's thesis, Cornell University, 1996.

Jewish Community Center. MSS 3668, WRHS.

Ruthalia Keim Family Papers. PG 275, WRHS.

Taylor Family History. MSS 4394, WRHS.

Women's Civic Club of Cleveland Heights. MSS 3641, WRHS.

Newspapers and periodicals

Cleveland Plain Dealer
Heights Dispatch
Heights Press
Heights Sun Press
Sun and Heights Press
The Plain Dealer